Women Holding Things

Women Holding Things

Maira Kalman

HARPER DESIGN

An imprint of HarperCollinsPublishers

What do women hold?

The home and the family.
And the children and the food.
The friendships.
The work.
The work of the world.
And the work of being human.
The memories.
And the troubles
and the sorrows
and the triumphs.
And the love.

Men do as well, but not
quite in the same way.

Sometimes, when I am feeling
particularly happy or content,
I think I can provide sustenance
for legions of human beings.
I can hold the entire world in my arms.

Other times, I can barely cross the
room. And I drop my arms. Frozen.

then

I am brought back to
my grandmother,
my mother, my aunts,
my sister, my daughter,
my granddaughters,
my cousins.
The women who
are my friends.

We have spoken to each other
for thousands of hours.

About all that can be held.

And not held.

And how sometimes

the water runs through our fingers.

And how sometimes

the cakes are baked

and the beds are made.

And the books are written.

The bed

and the books

and the cakes.

In my case, it is good to hold all.

Holding a specific thing
is a very nice thing to do.

You are standing there
 and you hold
 an enormous cabbage.
 Or a violin.
 Or a bright balloon.

That is a job in and of itself.
The simple act of doing one thing.

And perhaps someone you are walking with
will ask you to hold something for a minute
while they tie their shoelaces.

"Of course" is the answer.
"As long as you like."

woman holding chicken

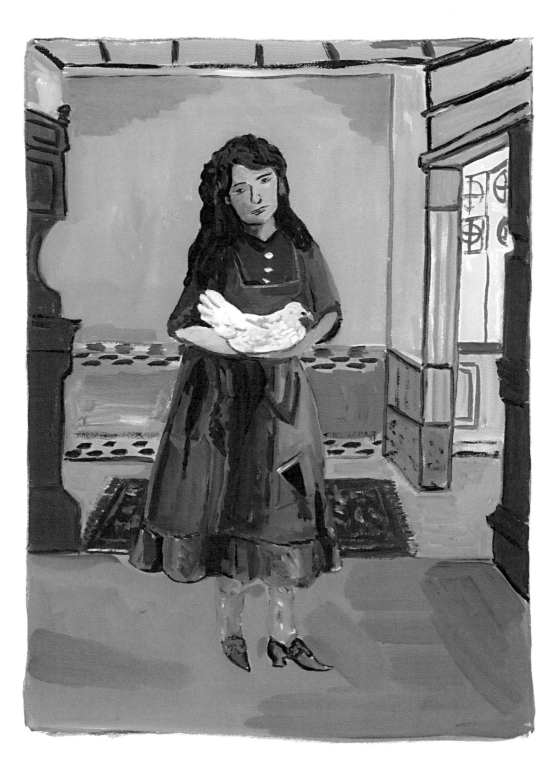

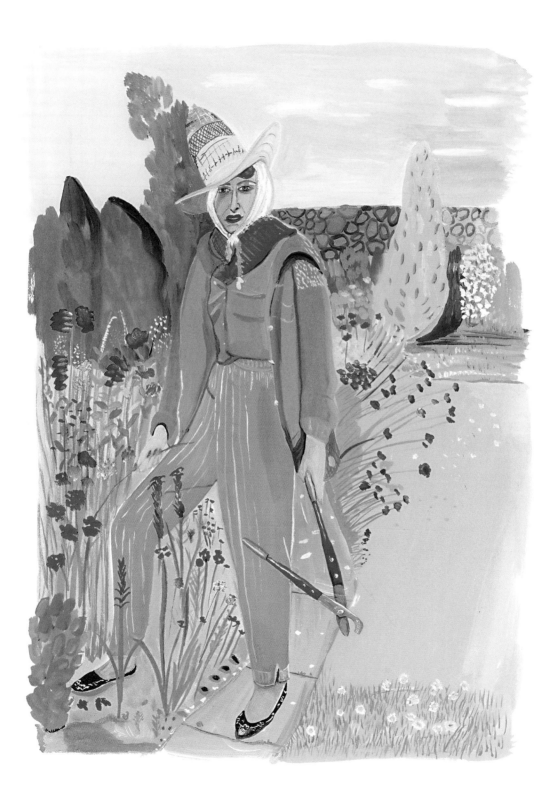

woman holding shears

woman holding
petite pink cup

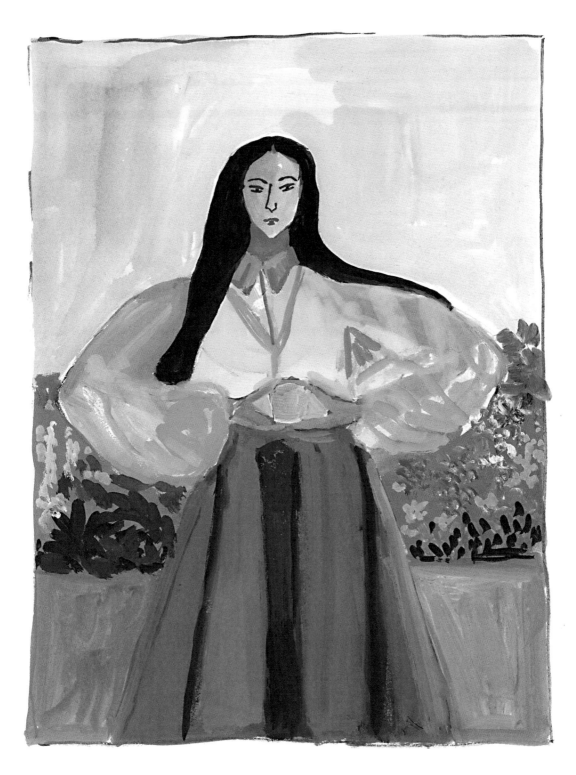

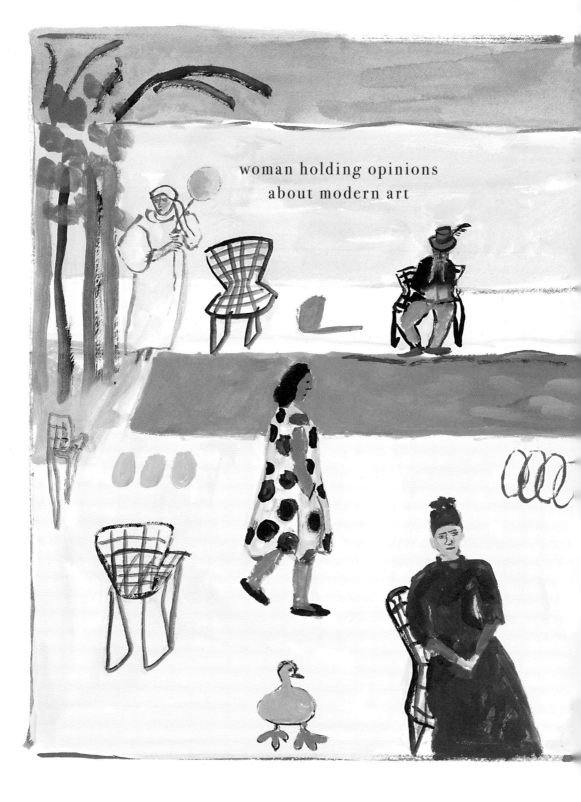

woman holding opinions
about modern art

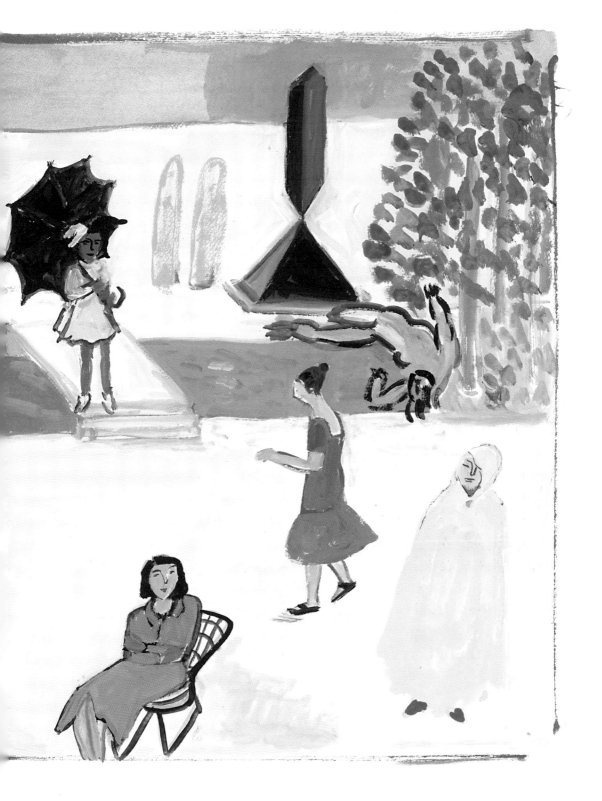

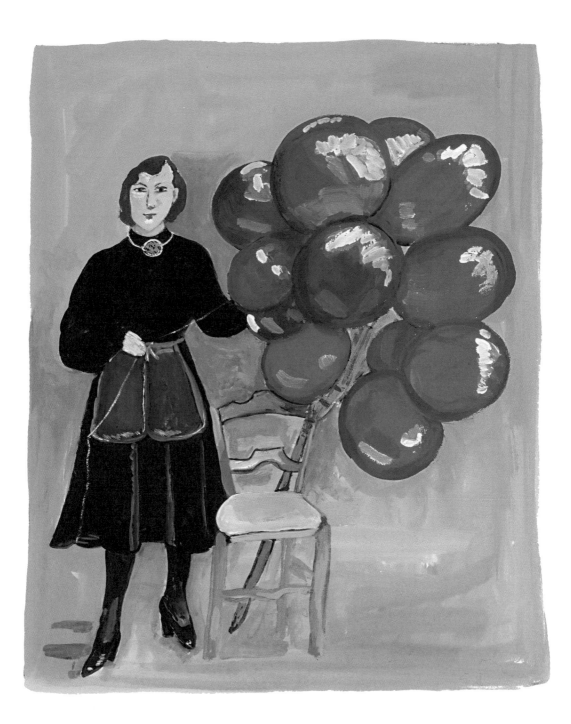

woman holding red balloons

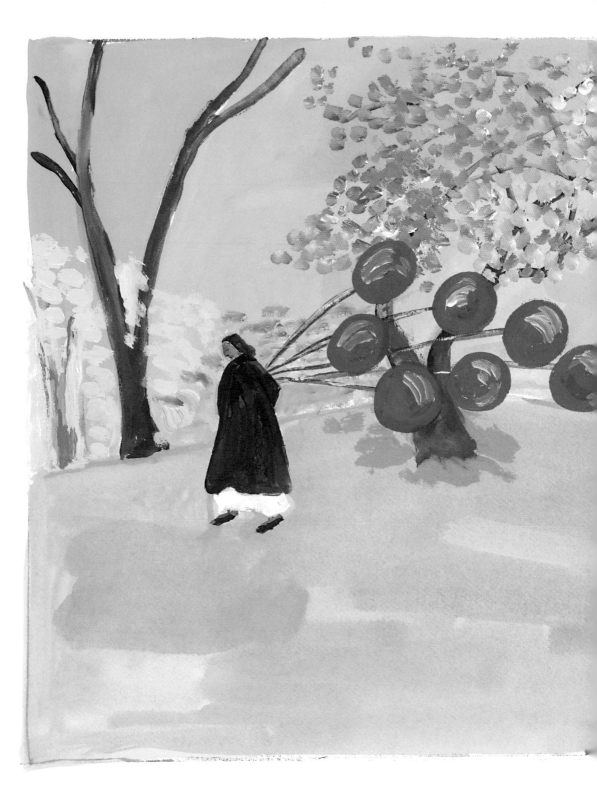

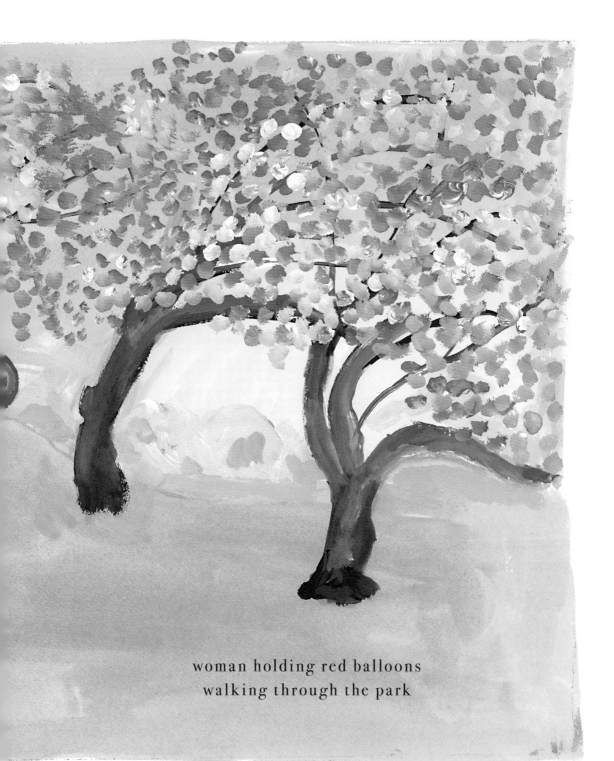

woman holding red balloons
walking through the park

woman holding book

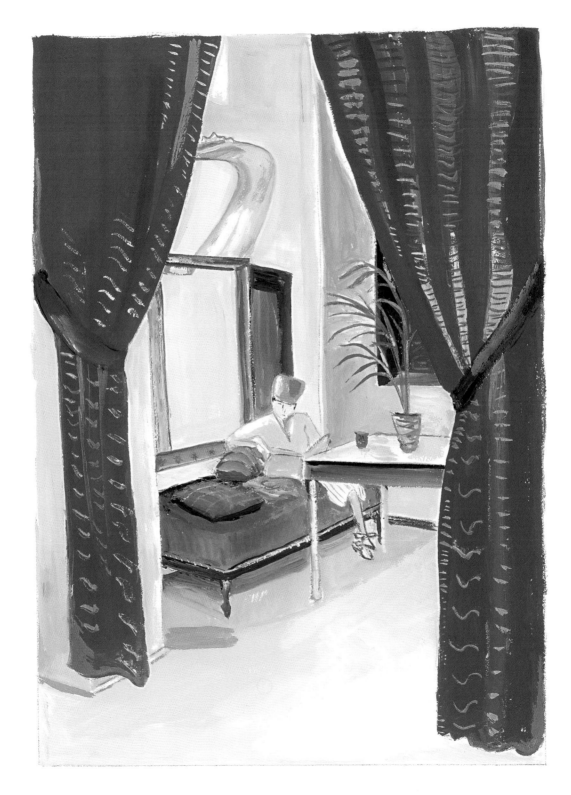

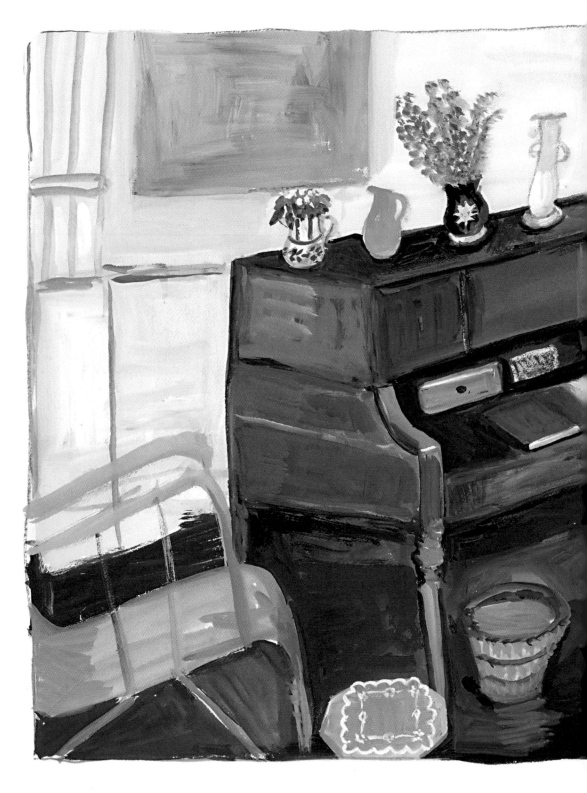

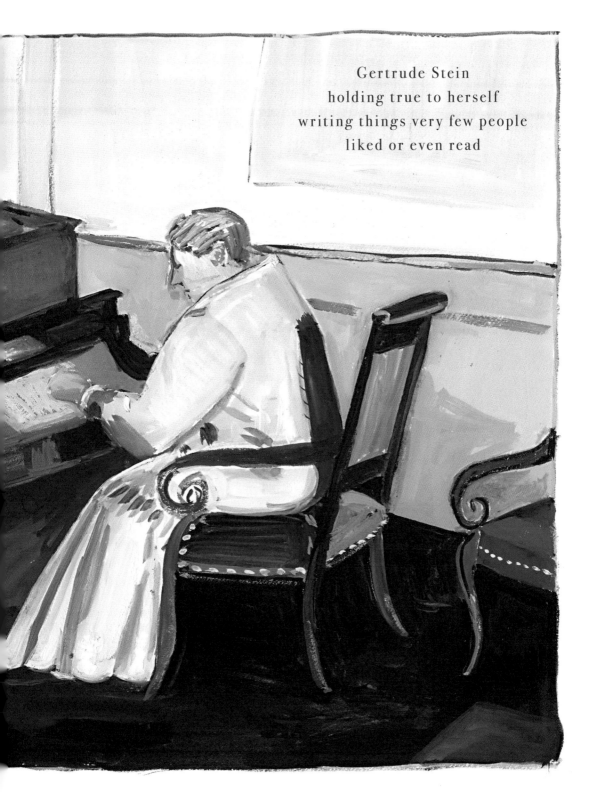

Gertrude Stein
holding true to herself
writing things very few people
liked or even read

Edith Sitwell holding ancient tree

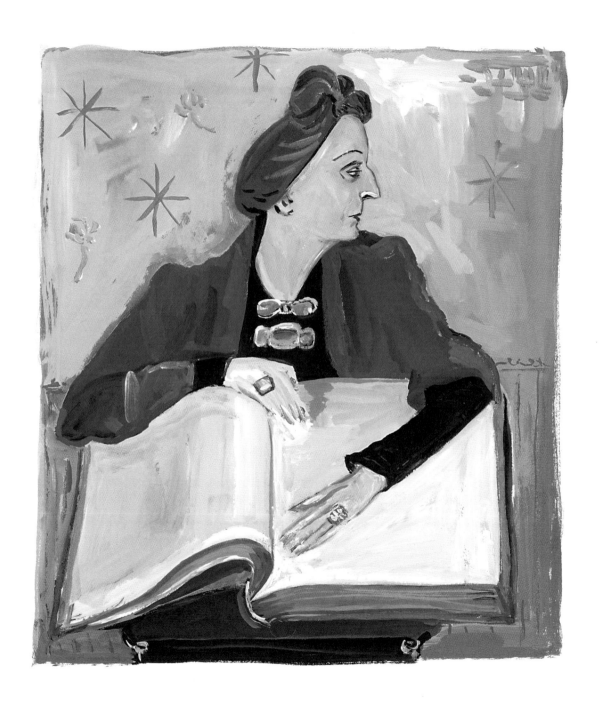

Edith Sitwell holding giant book

woman in my dream
walking through almond blossoms
holding a giant boulder

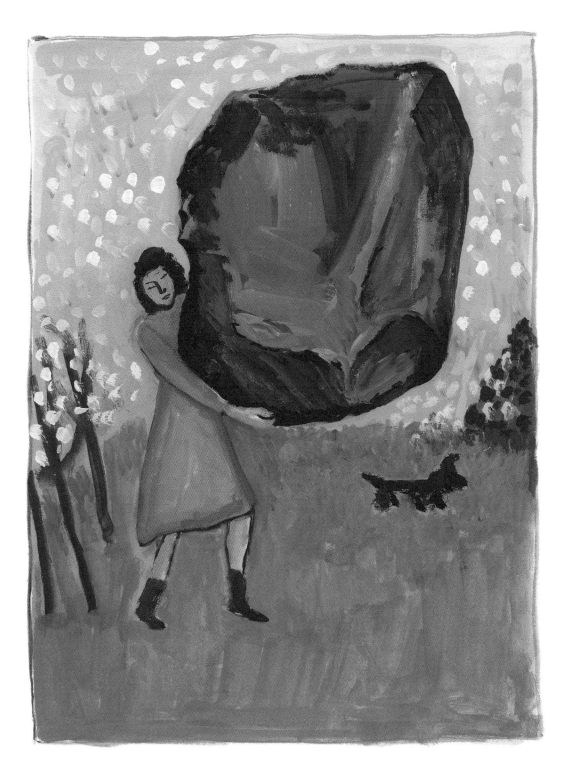

irritated woman holding giant cabbage

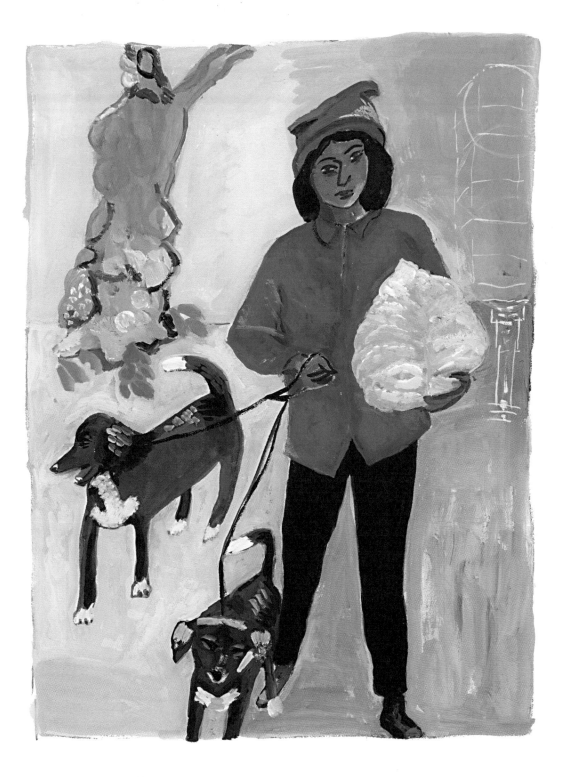

woman holding court

woman holding hand on green table

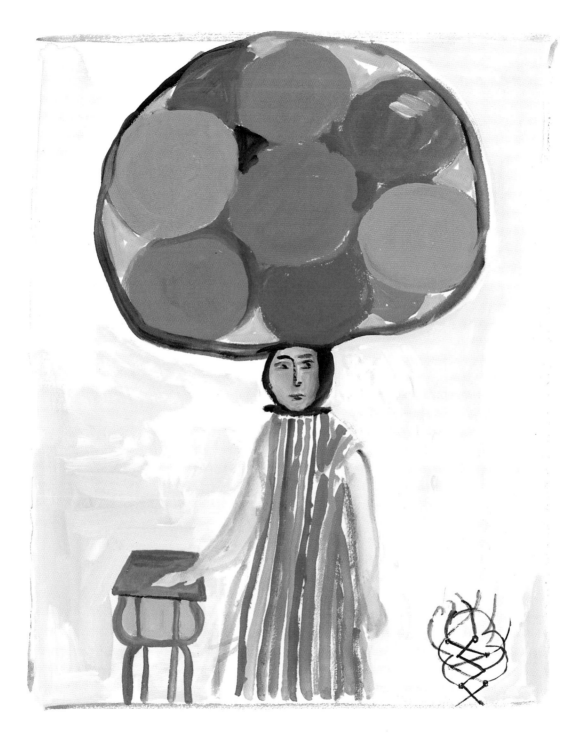

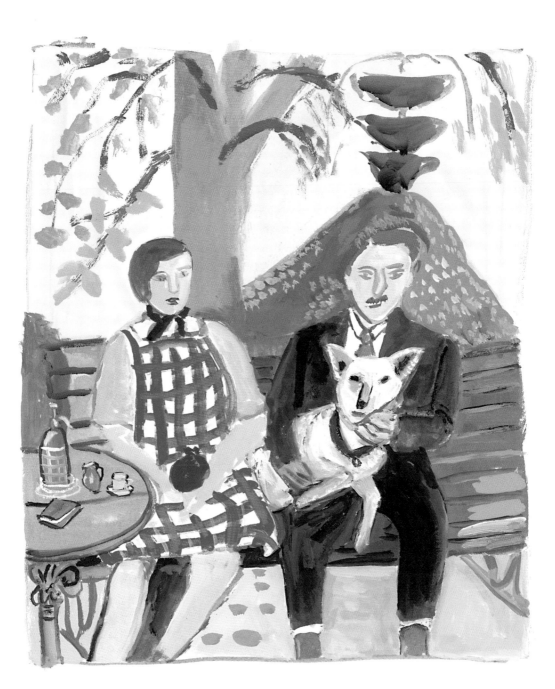

woman holding pomegranate

the woman holding the pomegranate
is the sister of the artist Louise Bourgeois

This is Louise's home in NYC.
She held the wolves at bay.
Or rather, invited them in.

If you invite the wolves in,
you can probably sleep better.
Though I am uncertain that she did.

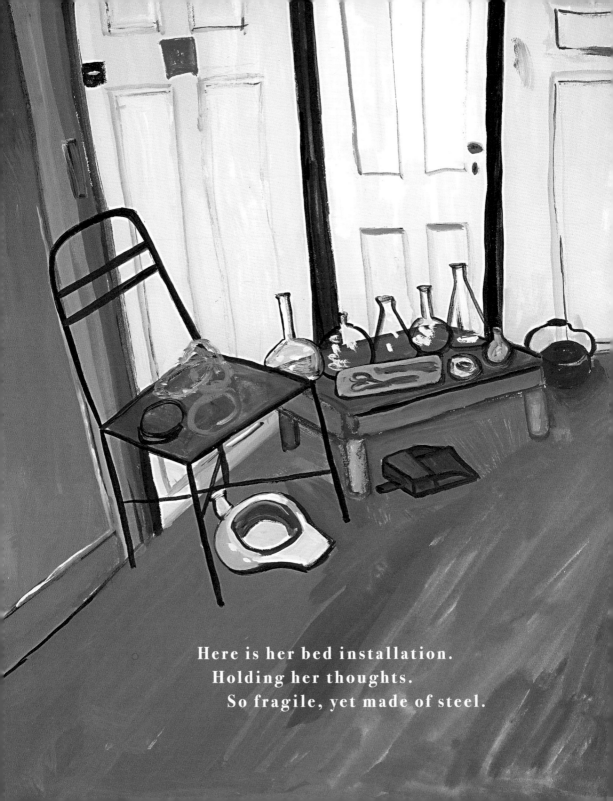

Here is her bed installation.
Holding her thoughts.
So fragile, yet made of steel.

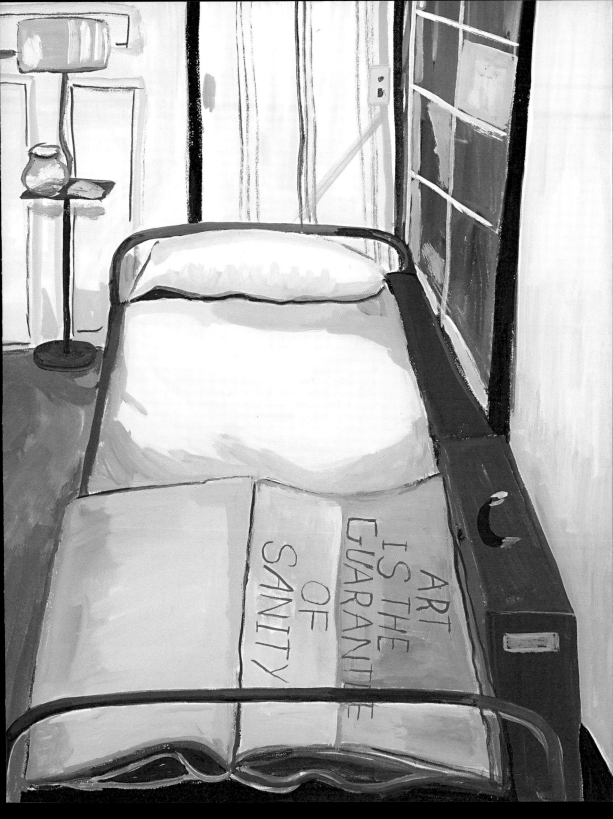

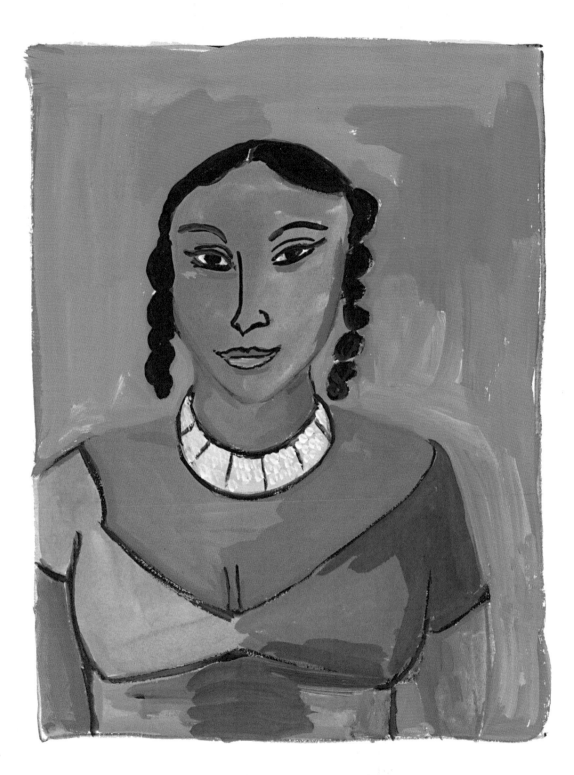

Ayana V. Jackson holding my gaze

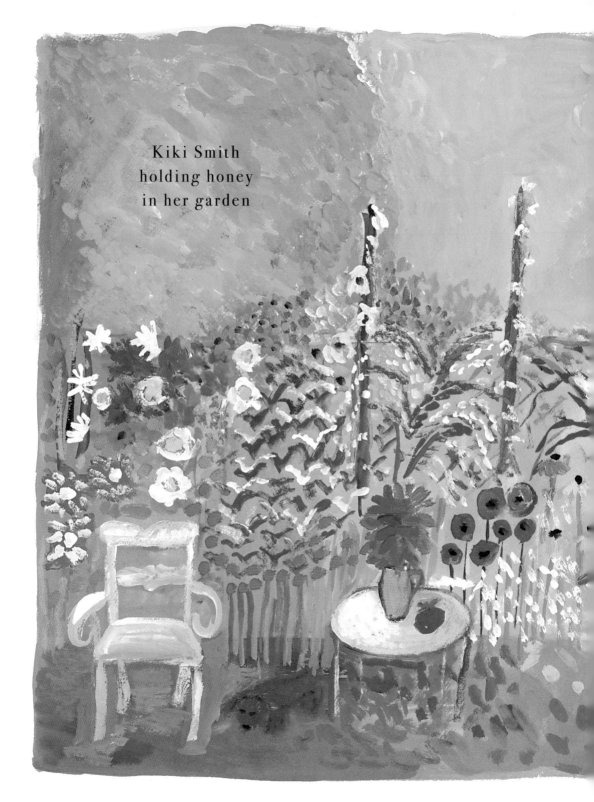

Kiki Smith
holding honey
in her garden

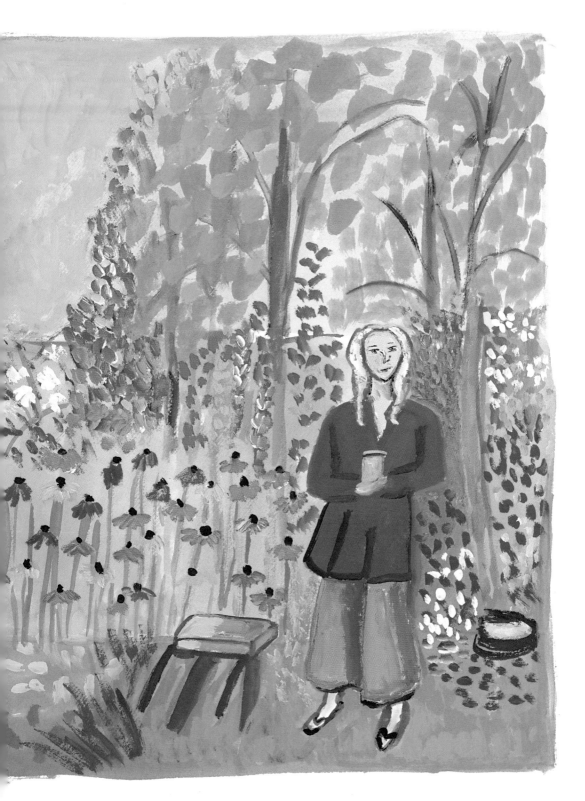

Hortense Cézanne
holding her own

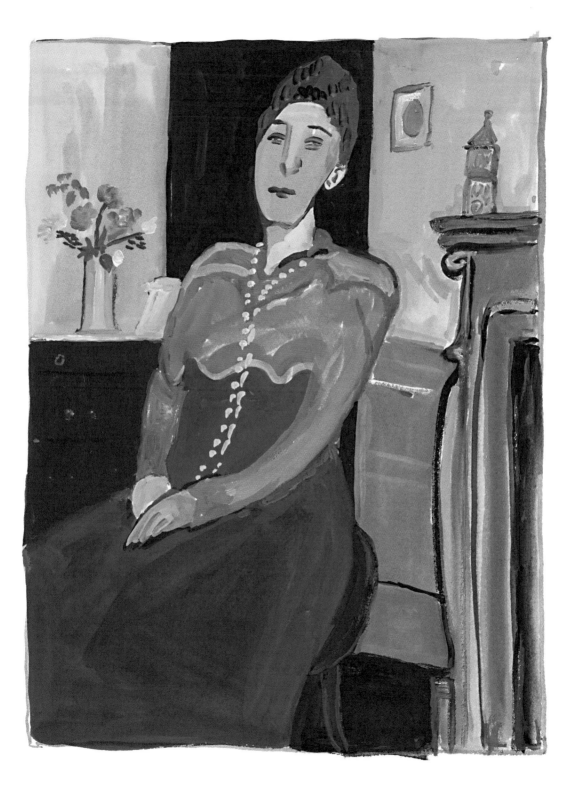

Hortense
holding granddaughter

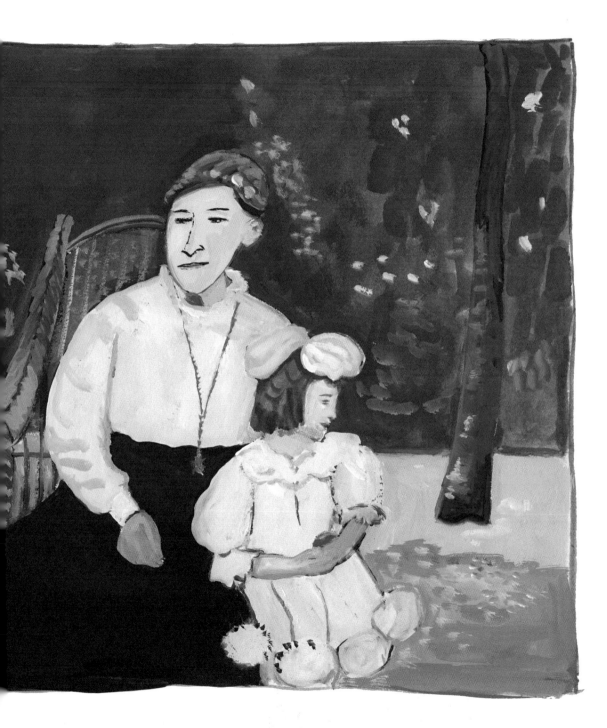

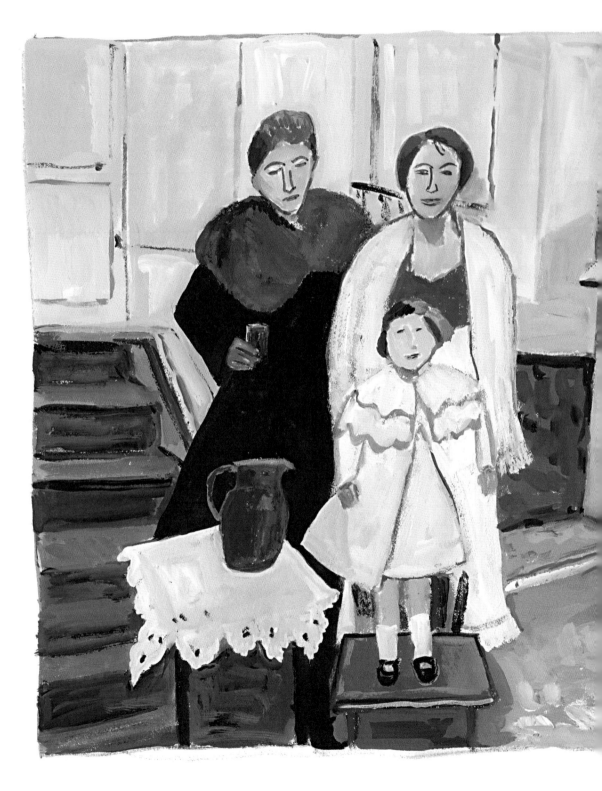

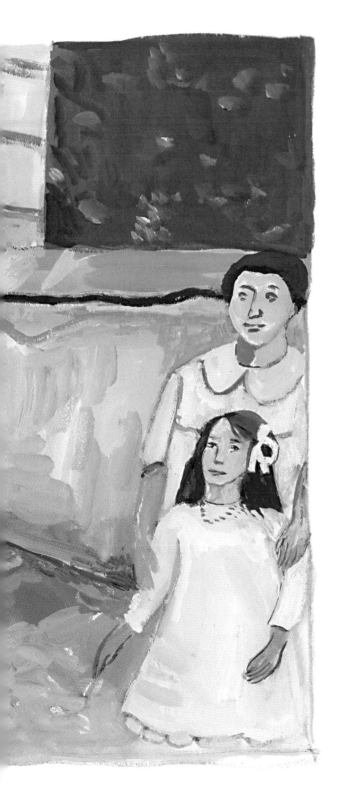

Hortense holding family
and glass of water

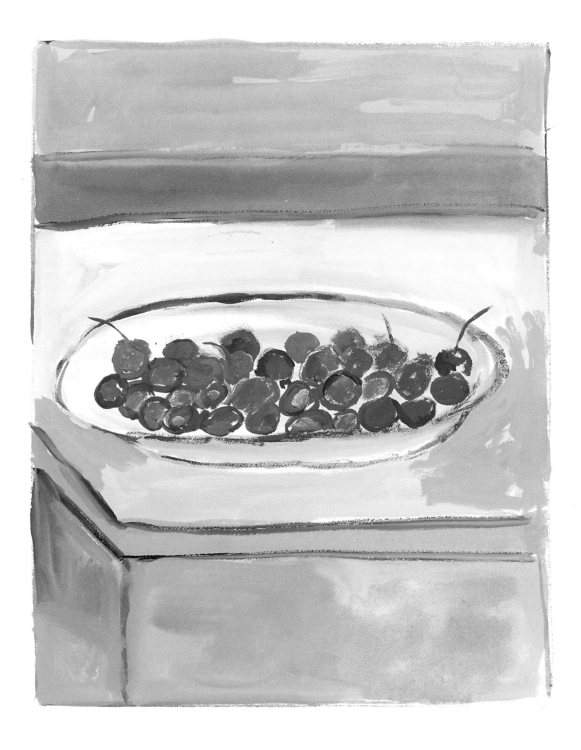

Cézanne's Cherries

Here is a bowl of Cézanne's cherries. The very bowl
he made a painting of. If he and his wife Hortense ate
them, I cannot say.

If Cézanne and Hortense bickered or disagreed about
something or perhaps all things, I do not know. They
could have bickered about what color to paint the wall,
or what slipcovers should be on the chairs, or how
much attention he paid her. Or she him.

When I think about them disagreeing, bickering,
being sullen, brooding and moping and then him
painting cherries, or trees, and painting her over
and over, I am heartened. And settled inside. Because
every day is a struggle, and it is not easy. But if you
can paint a bowl of cherries, that is something.

My friend (male) told me that if I eliminated the word
happiness from my vocabulary, I would be happy.
I am inclined to agree.

My mother also told me the same thing,
but I was too young to understand.

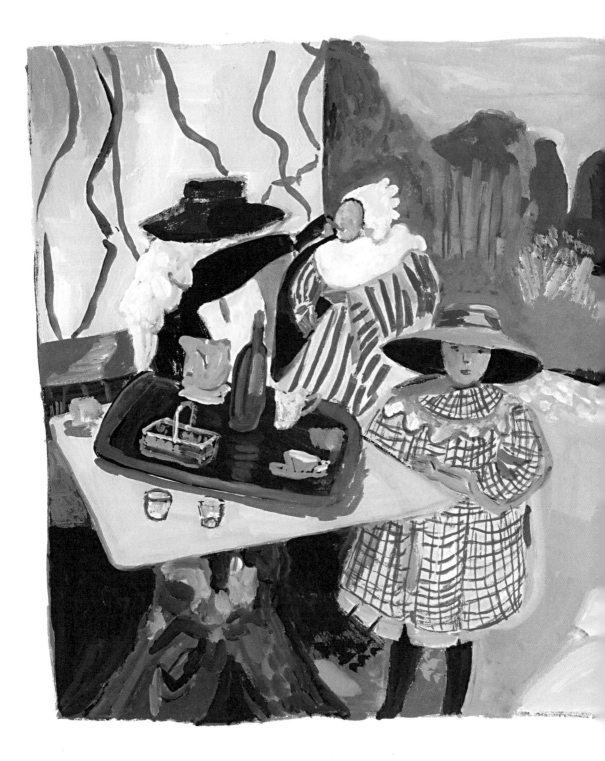

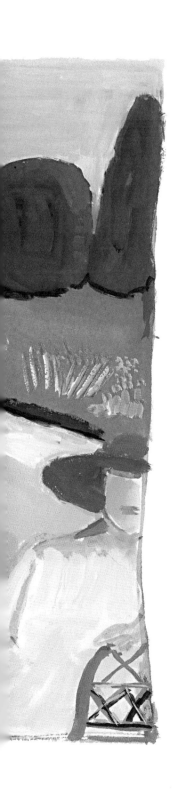

woman holding
baby in garden

woman
holding
consoling
and comforting
her daughter

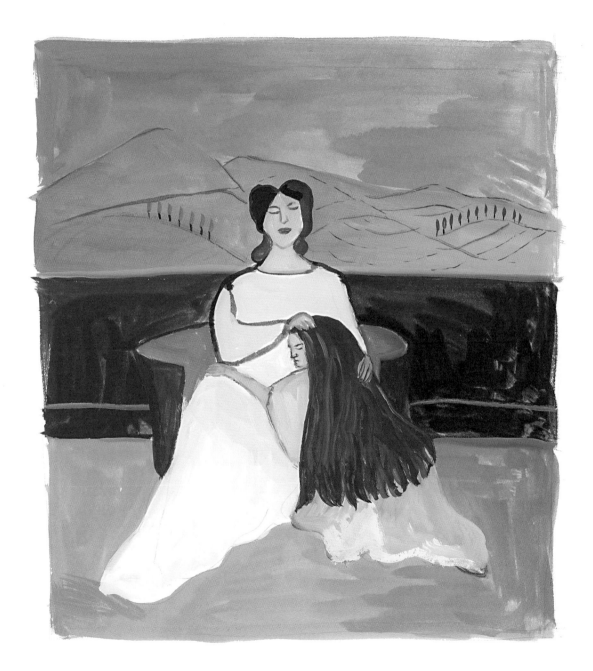

woman (Lotte Lenya)
holding man (Peter Lorre)

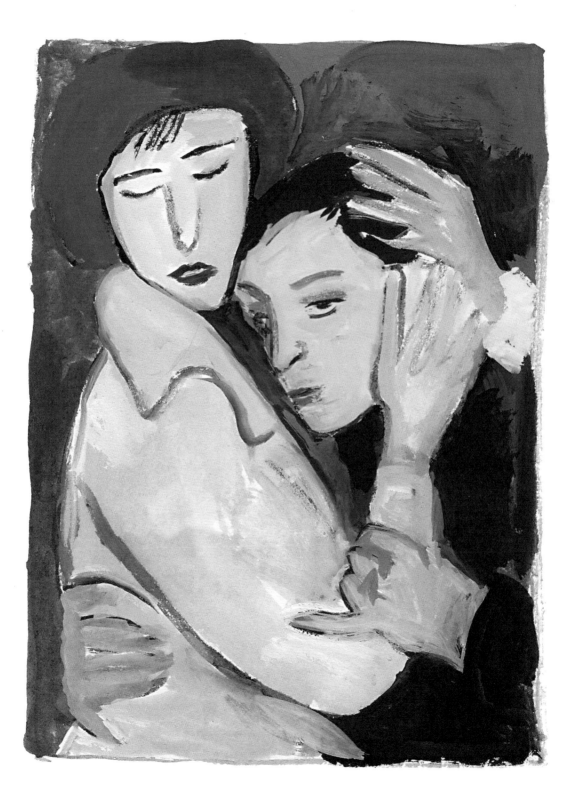

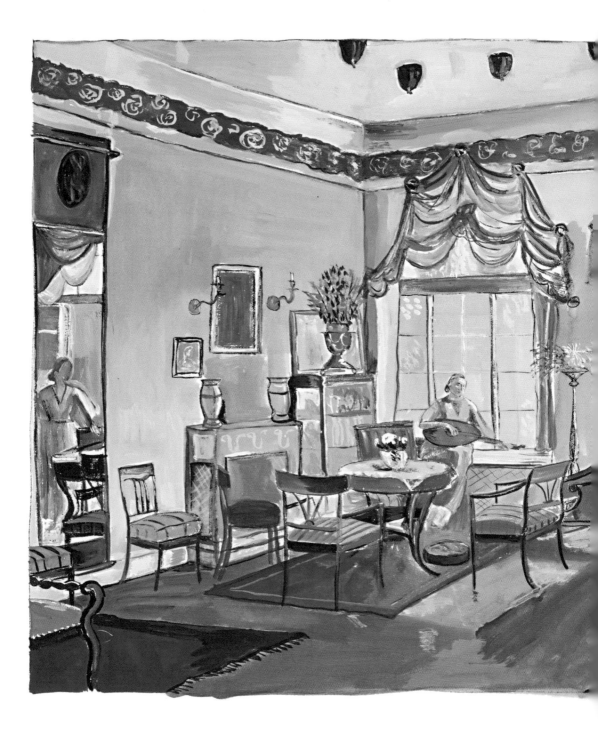

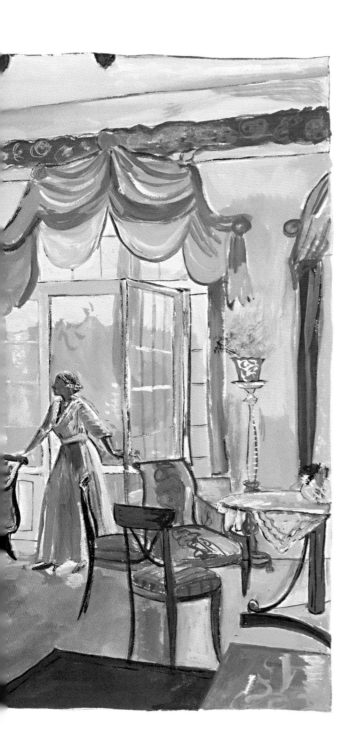

woman
holding
lute
while her sister
looks on

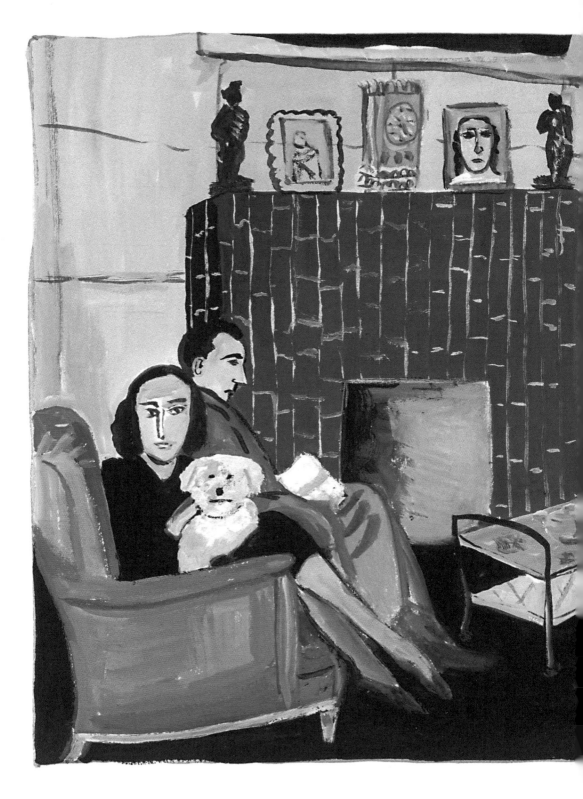

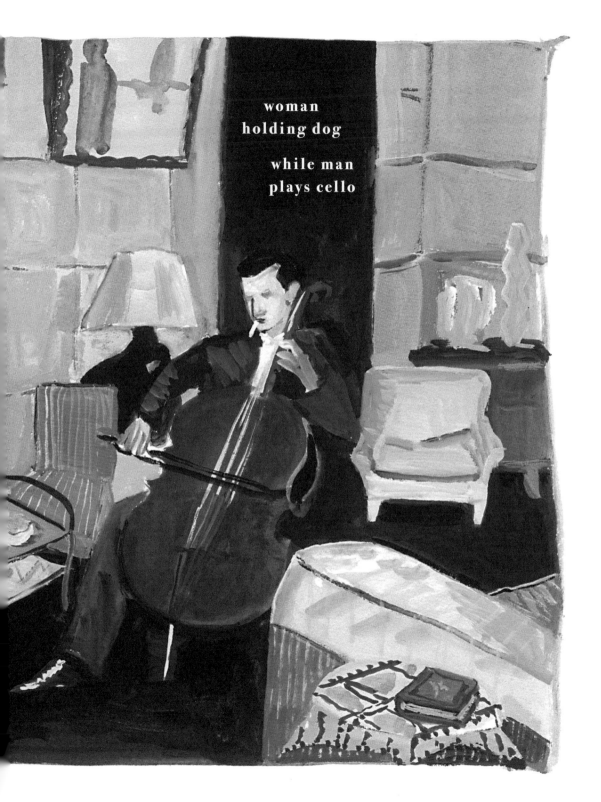

woman
holding dog

while man
plays cello

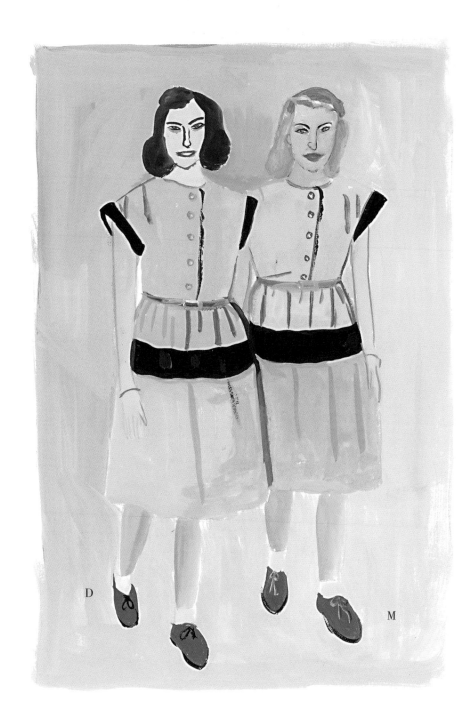

women holding a grudge

The women in this painting are my
mother-in-law Marianne, and her twin sister Dolly.
 Is it unfair to say they hated each other
 from the day they were born?
 But really, that was the case.

 Marianne would recount the ways
 Dolly betrayed her. Yes, betrayed.

In Budapest, after the war, Dolly sold Marianne's
letters of transit (is this a scene from Casablanca?).
But Dolly was Hungarian and therefore
 Unrepentant.
 Undaunted.
 Unapologetic.

There is something to be said for being unapologetic.

 Marianne gave birth to Tibor.
 She did not know at the time that he
 would meet me and we would fall in love
 and marry. And that I would replace her
 in his affections. For me, he held the key.

Marianne and her husband George had an open marriage. In that they both had dalliances. Nothing separated them until Marianne, in their final years at a retirement community, fell in love with Conrad, who also was a resident there.

Because they were all living in the tiny community, Marianne tried to keep it a secret from George. She could not be that open.

One day, Conrad and Marianne took a secret trip to Paris, having told George that she was going to visit her sister Dolly in Canada. No sooner had they left for their tryst, when Dolly called George, and told him where Marianne was not and where she was.

Where she was,
was in a beautiful apartment on the Île St-Louis.
Every morning, Conrad brought Marianne
croissants and coffee on a tray.
A honeymoon of sorts.
They went to Parc Monceau.
They went to the Nissim de Camondo Museum.
They went for romantic dinners at Chez Georges
 (which is ironic).
And then they returned home.

George moved out of their house.
He was almost 90
and couldn't abide this romance.
In the end, George died in Marianne's arms.
And a few years later,
Conrad died in Marianne's arms.

Nothing is easy.

woman holding
lipstick and giant bow
at Chez Georges

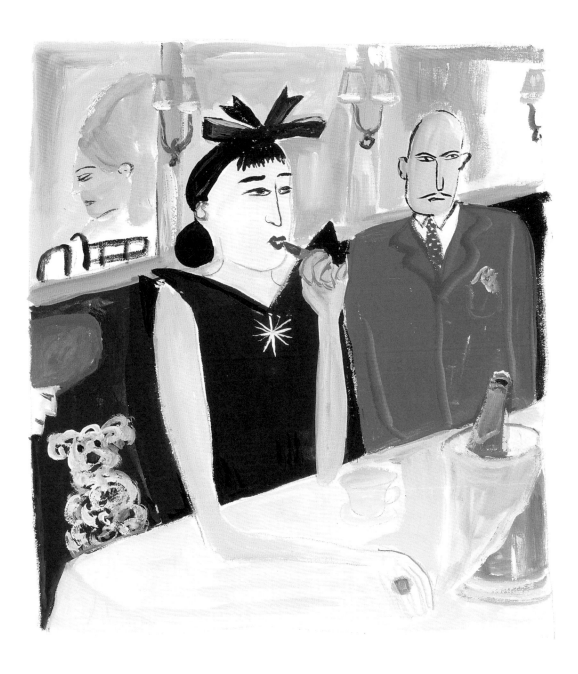

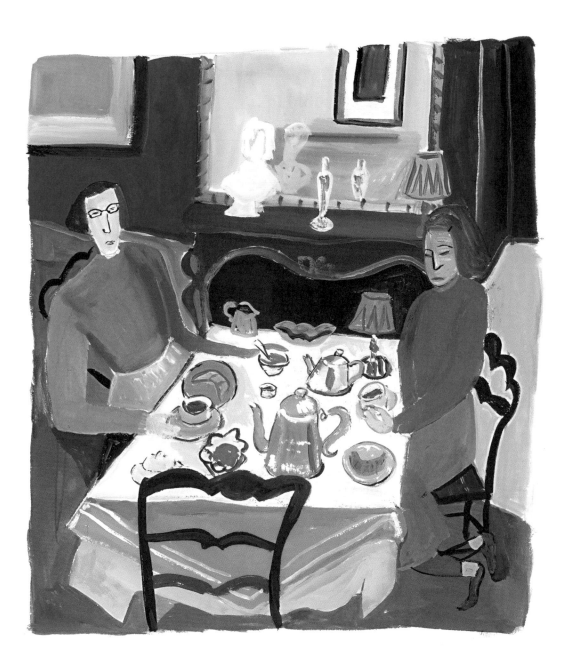

woman holding on to terrible mood
from bad dreams the night before

in various dreams,

birds have latched onto my nose
or attached themselves to my neck

I have fallen from great heights

kissed people I never could in real life

driven cars completely out of control

been separated from my mother on a raft
in the cold ocean in the dark of night

suffered loss, catastrophe, havoc, terror

and have often been confused
or bereft by the dream

once in a while everything is
completely benign or even delightful

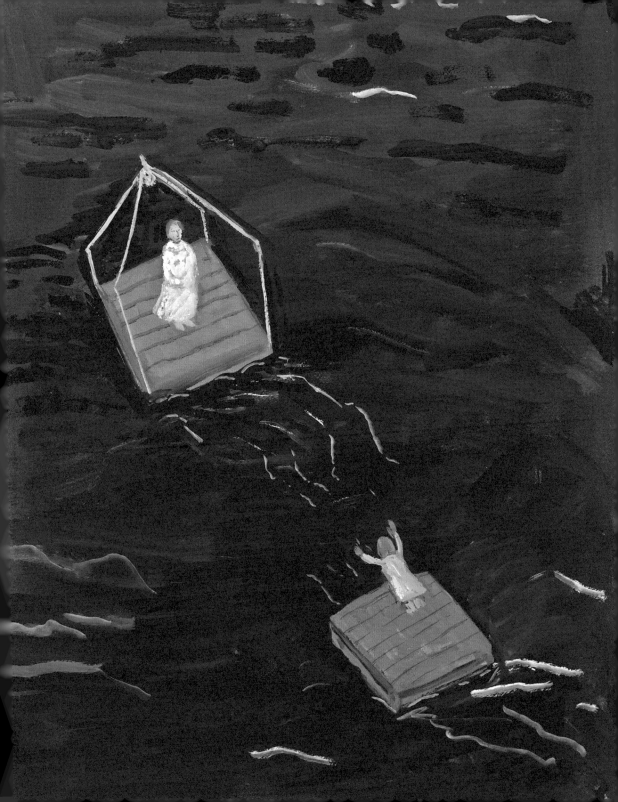

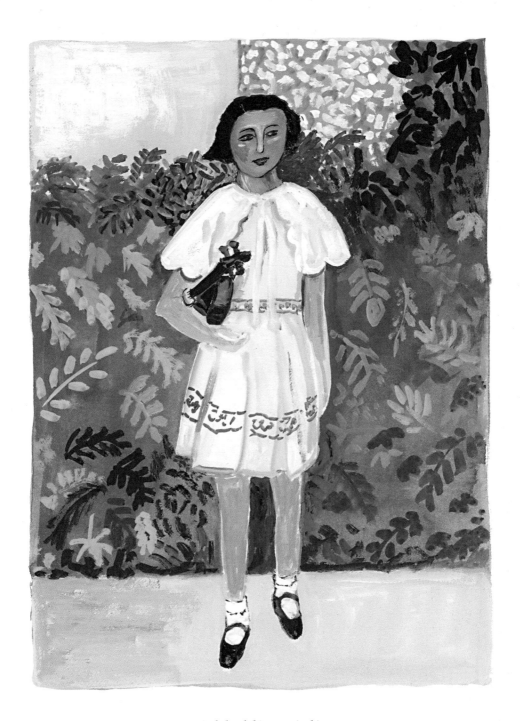

girl holding violin

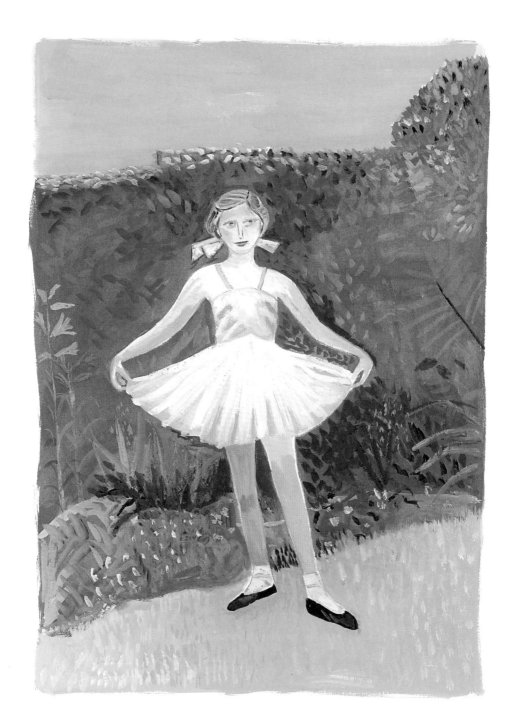

girl holding tutu

girl holding doll and book

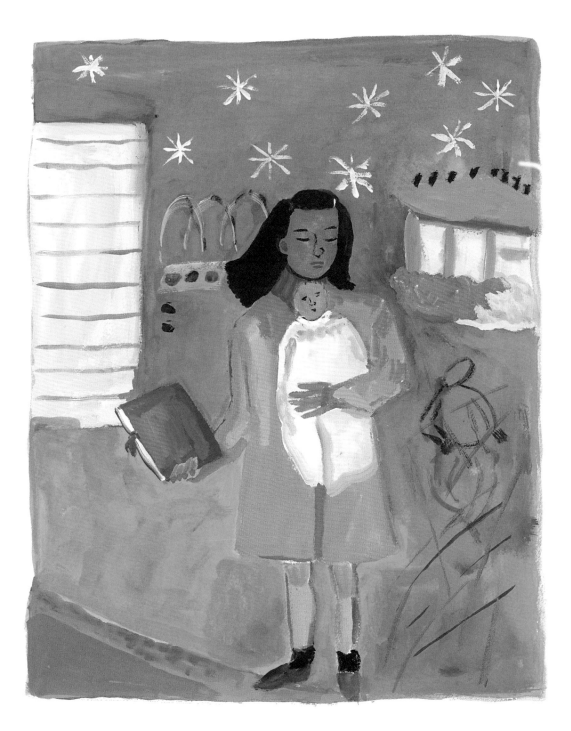

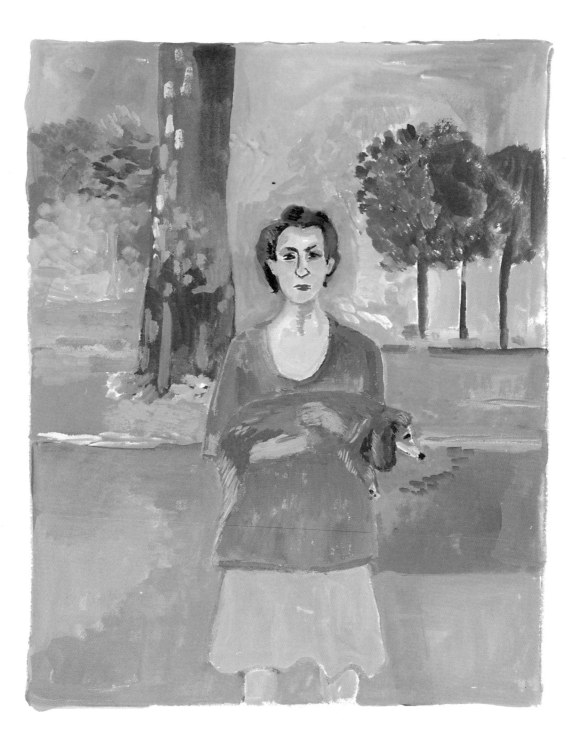

woman walking down the street
holding her sick dog

Julie holding Augie

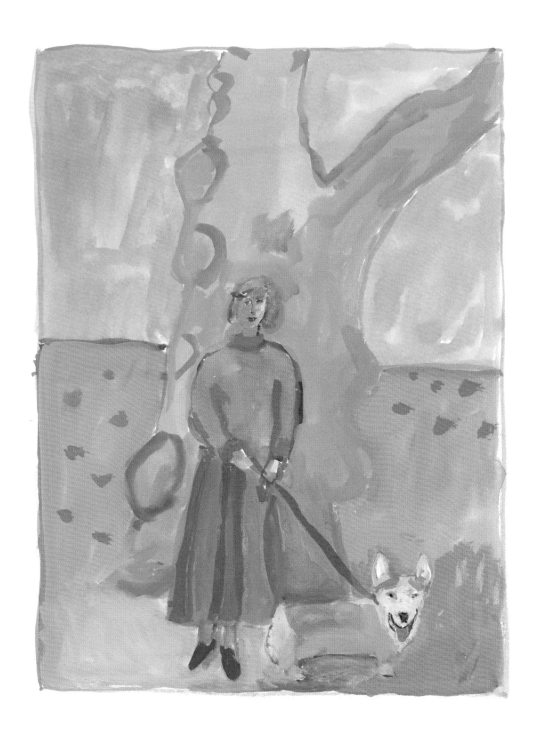

Elizabeth holding Hugo

In our walks through the park, Elizabeth and I
have seen dogs dressed and undressed. Trees bare,
leafing out and blossoming. Cherry trees. Lilac trees.
Littleleaf Lindens. Filling the air with perfume.
Fields of flowers popping up and dying down.
Light and shadow always changing and shifting.

And through these walks, a vast array of people.
Most seen only once. But some constants.
The tall thin philosophers exchanging ideas, with
measured walk. The short waddling twins with coke-
bottle glasses and long, fuzzy, gray hair parted in the
middle. The loud man who looks like Humpty Dumpty,
striding quickly and voicing loud opinions on the
phone. The sweet man we call Dolce, who is always
perfectly turned out in cap and scarf walking his little
dog. We are crisscrossing strangers, wending our way
through numerous paths.

I find seemingly superficial serendipity very satisfying.

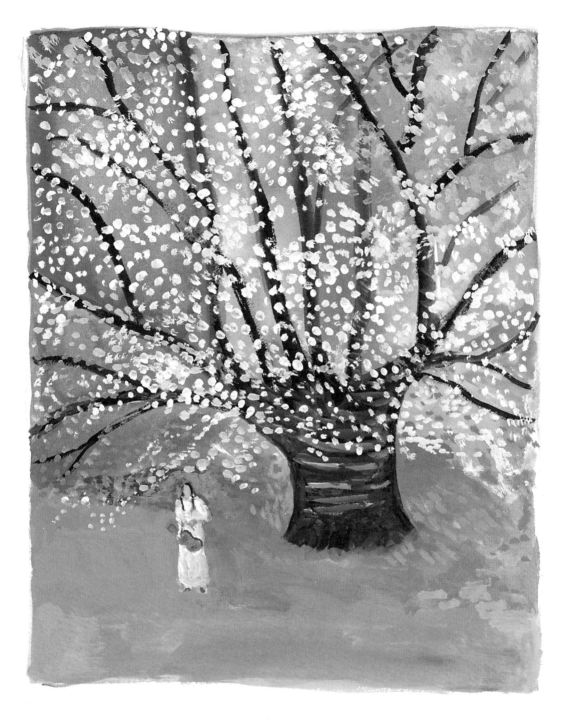

woman holding a pink ukulele under a giant cherry tree

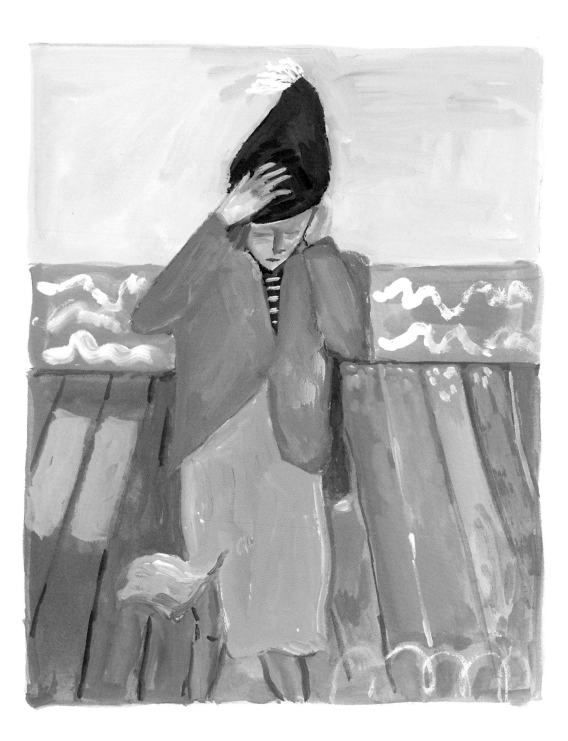

woman in pink skirt
holding on to her hat

woman holding up

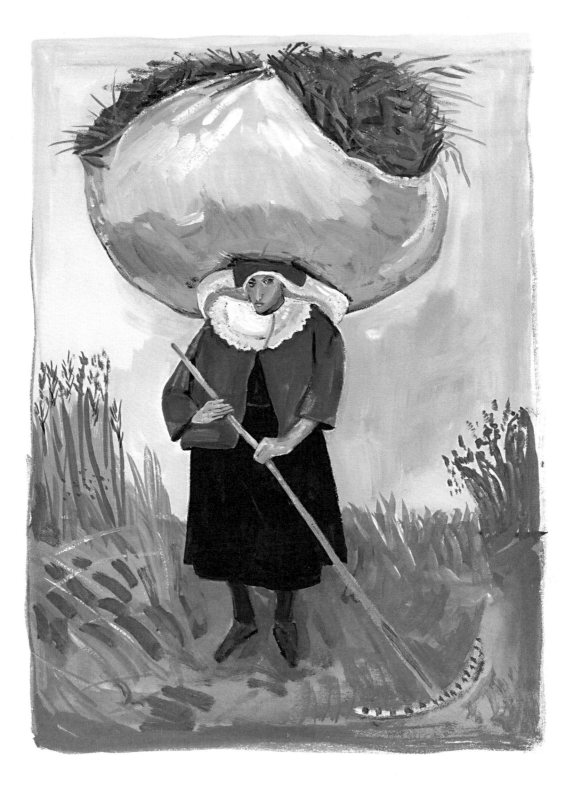

Dan Bora's Romanian grandmother, Emilia,
holding a whisk, preparing papanasi.

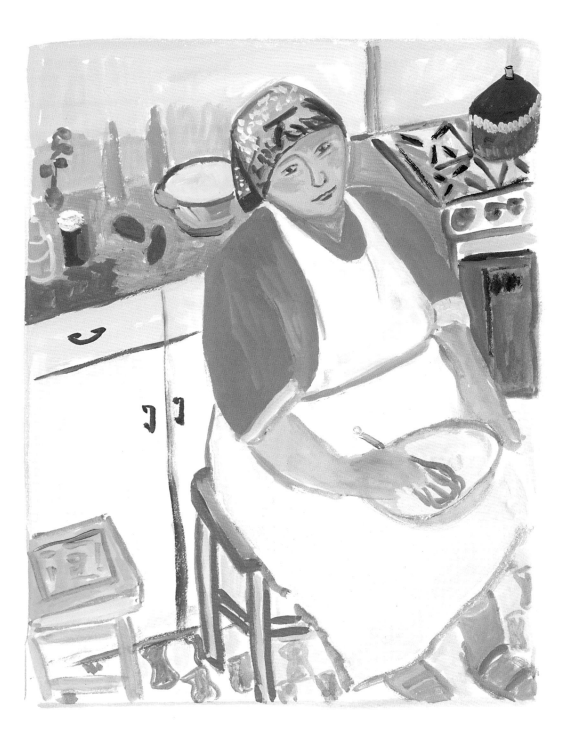

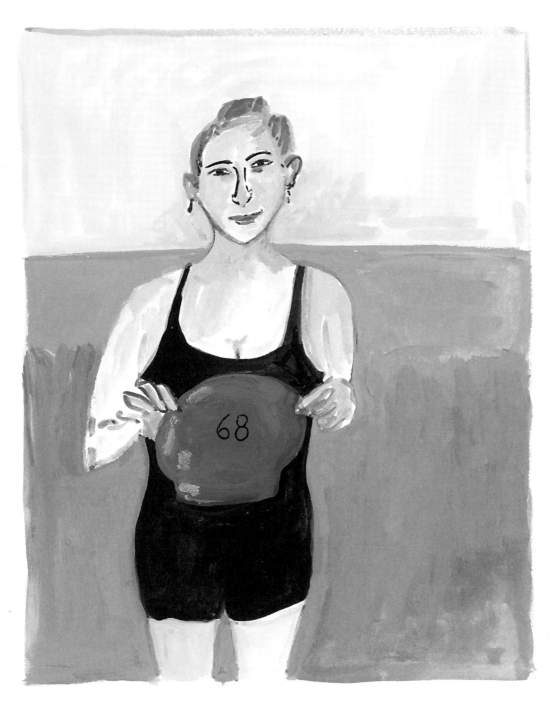

woman holding her red cap after
swimming across the Hudson River

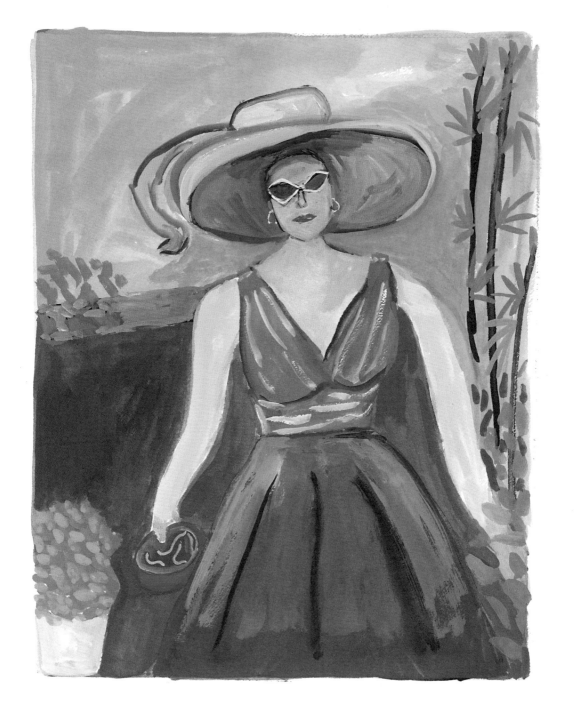

glamorous woman holding a can of worms

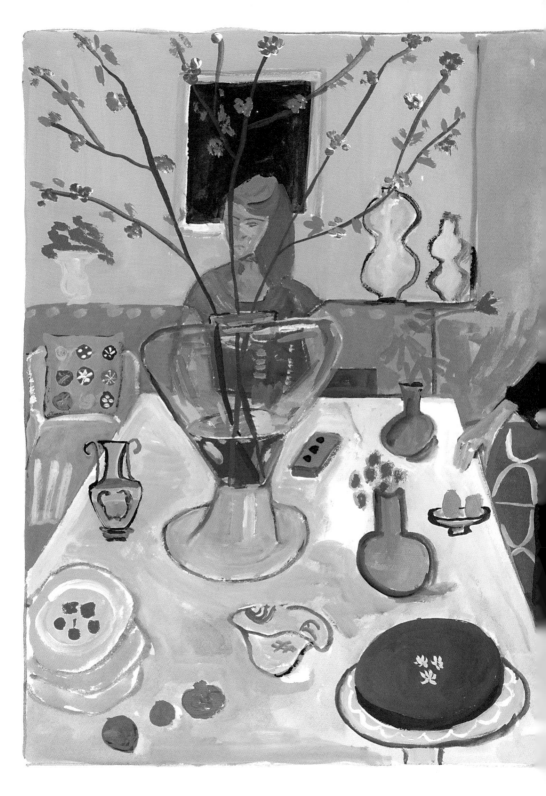

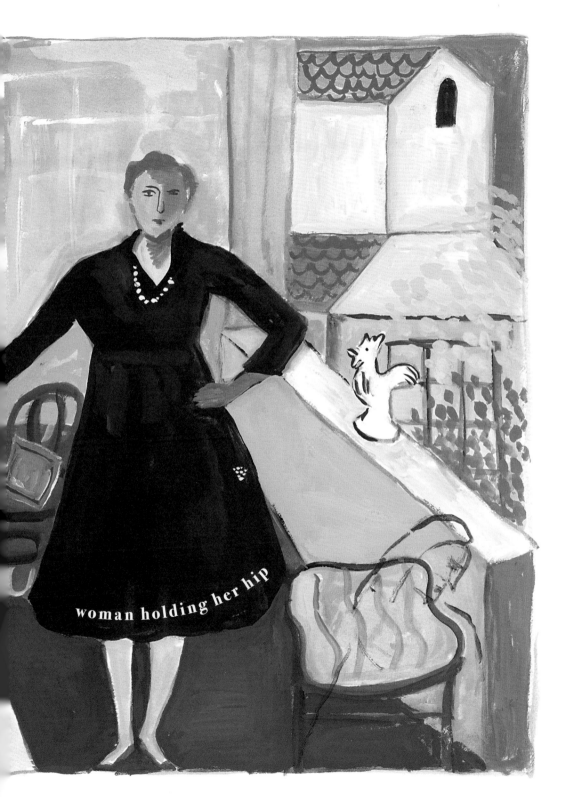

woman holding her hip

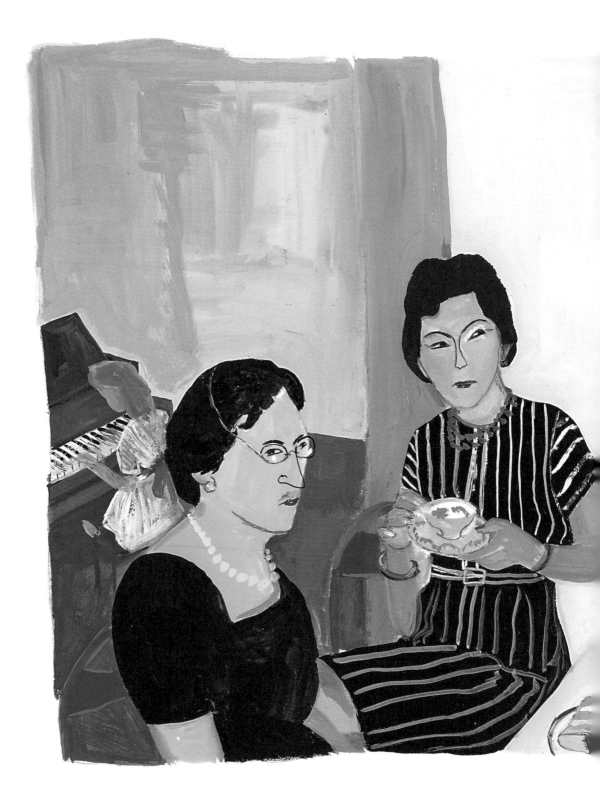

women holding
malicious opinions
while I play the piano

The woman on the
left is my aunt Tilleh
(a dentist with a mustache).

The woman on the
right is my aunt Pipkeh
(a bitter pill if ever
there was one).

Pipkeh had so many
malicious opinions.
Giving them not
a second's thought.
In fact, I think they
were her delight.

Speaking of malicious opinions,
E. F. Benson wrote a series of books about
Mapp and Lucia, two women who are rivals
living in a tiny, quaint village in England
between the wars. The acerbically and astutely
described comings and goings and doings of the
characters echo your life and my life. Hilariously.

Here is E. F. Benson's garden room, destroyed
in a German bombing raid during WWII.

The Bechstein piano is clearly beyond repair.
The radiator stands stalwart and strong.
But the chair is holding on for dear life.
I don't know what happened to the chair.
But I can guess.

How much I love things and the stories they tell.
If I can love a chair as much
or more than I love, let's say,
my aunt Pipkeh,
what does that say about the chair?
Or Pipkeh?
Or family?
Or love?

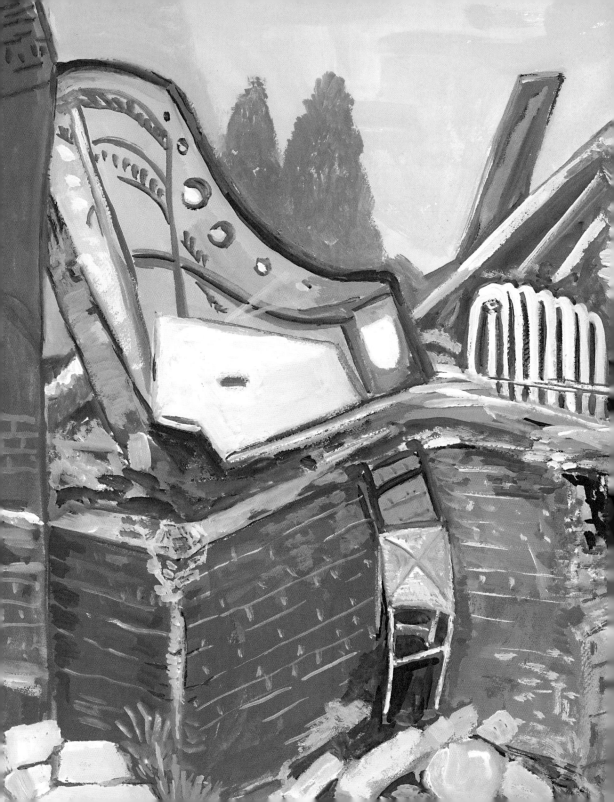

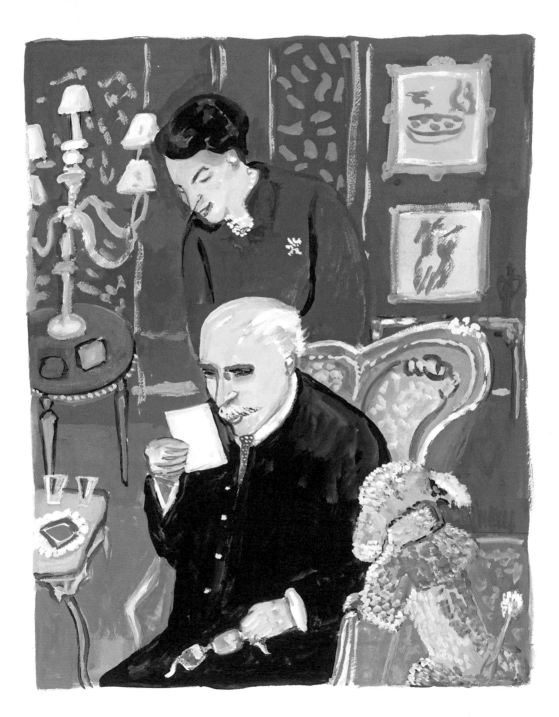

woman standing behind a man holding a letter

Isn't that how it always was?
The man with the woman behind him.

In this case, it is the brilliant, tempestuous,
conductor Arturo Toscanini and his daughter Wanda,
with their poodle, whose name I do not know.

Wanda aspired to be an opera singer.
But Toscanini found her singing intolerable.
So singing was forbidden.
Instead, she helped her mother take care
of her father. Her father, who had many
dalliances and great love affairs.

Ultimately,
Wanda married Vladamir Horowitz,
the brilliant and complicated pianist.
Now there are two poodles in the picture.
And two impossible men to take care of.
It may have been an interesting life.

But still.

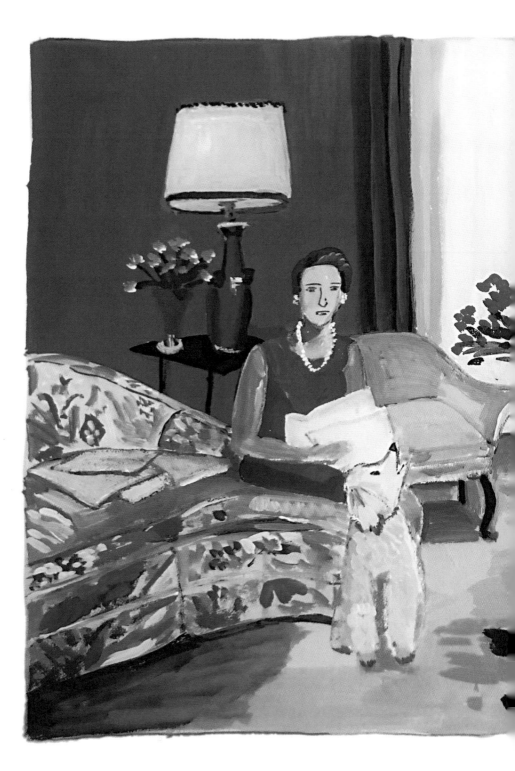

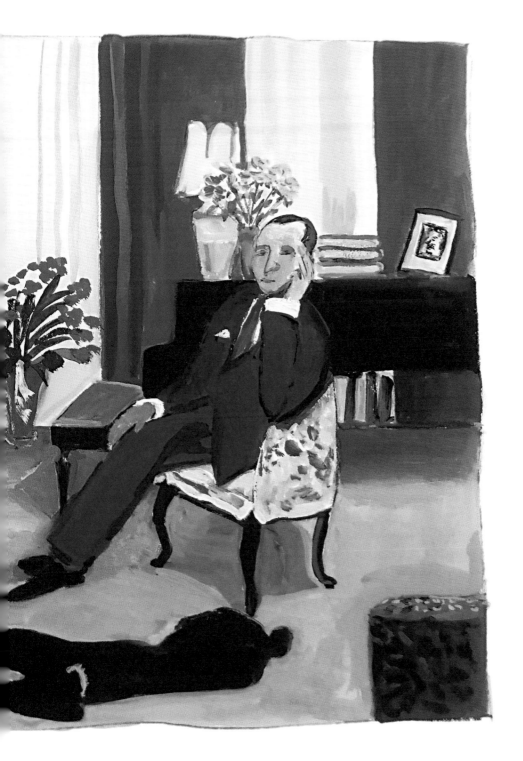

Virginia Woolf
barely holding it together

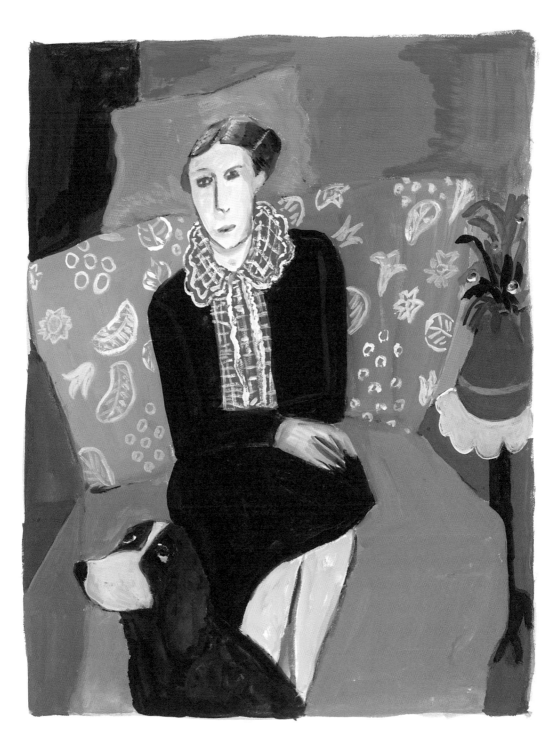

Sally Hemings
holding history accountable.

I don't know why,
but she reminds me of my mother.

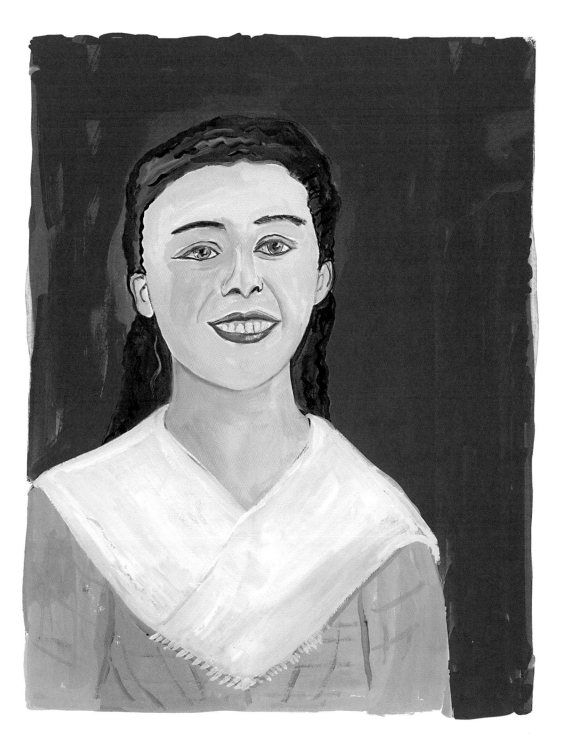

my mother holding her sister
the day of her ill-fated marriage

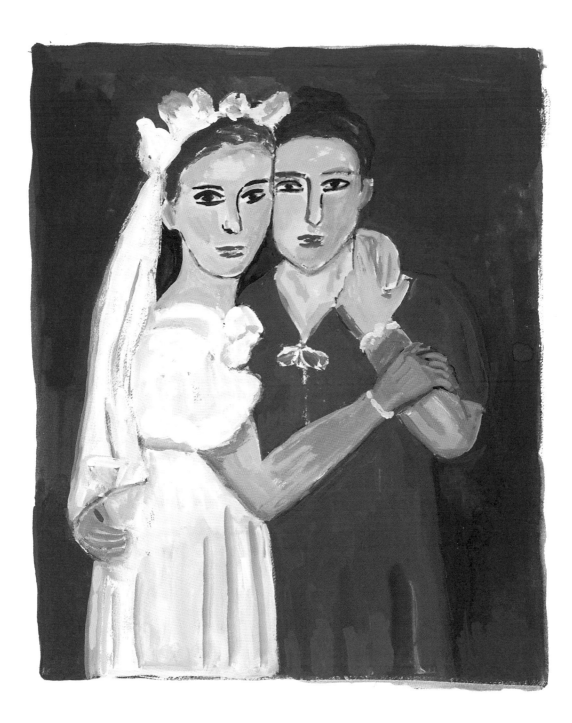

My mother would ask us
"what is the most important thing?"
We knew that the correct answer was Time.

You could say that my mother lost a great
deal of time to an unhappy marriage.
But how unhappy was it? Shakespearean level?
Run of the mill unhappy? Impossible to say.
I can't ask her because she is no longer alive.
But she ultimately left my father
and found her time.

Finding time is all we want to do.
Once you find time, you want more time.
And more time in between that time.
There can never be enough time.
And you can never hold on to it.

It is so strange.
We live. And then we die.
So unutterably strange.

A word about my father.

His name was Pesach. He came from
the little town of Volozin in Belarus.
His family owned a dry goods store
and were well-to-do. Before the war,
he went to Palestine with two brothers.
The rest of his family stayed in Belarus.

You know what happened, of course.
You have heard it a thousand times before.
They all perished.
Shot and dumped into a mass grave.

My cousins and I visited that little
village. I called it THE TRIP OF
VISITING WHAT IS NO LONGER THERE.

What did my father hold?

He held me.
He held his side of the bargain.
He paid for everything.
We ate well. We dressed well.
We traveled well.
I had dance lessons and piano lessons.
He took me ice skating.

What else did he hold?
The anguish of losing his family.
Perhaps that anguish led him
into a strange, irrational land.
He had dalliances. Many.
He became more and more distant.
Suspicious. Angry. Hurt.

What did he not hold? I am sad to say,
as I got older, my love and understanding.

Maybe now, so many years after his death,
I can say he deserved better. And did the
best he could. But that is easy to say, now.

(By the way, when I was young and looking at
this photo, I was certain my father only had
one leg. So how reliable could I possibly be.)

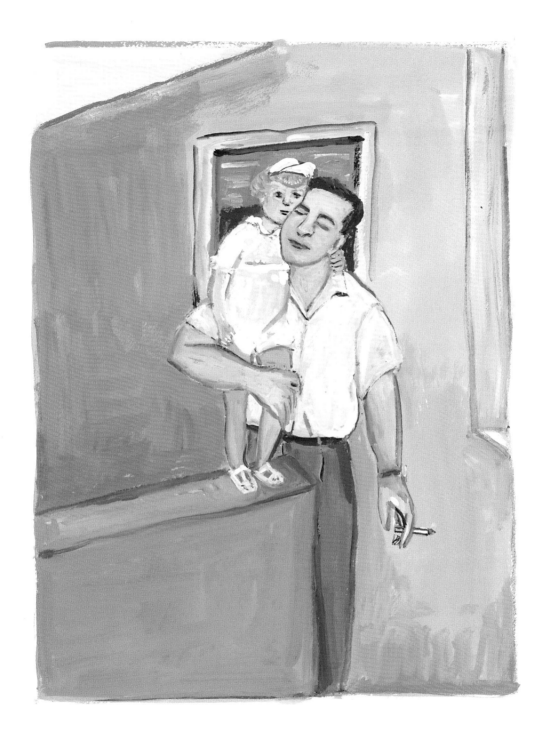

Pesach holding Maira

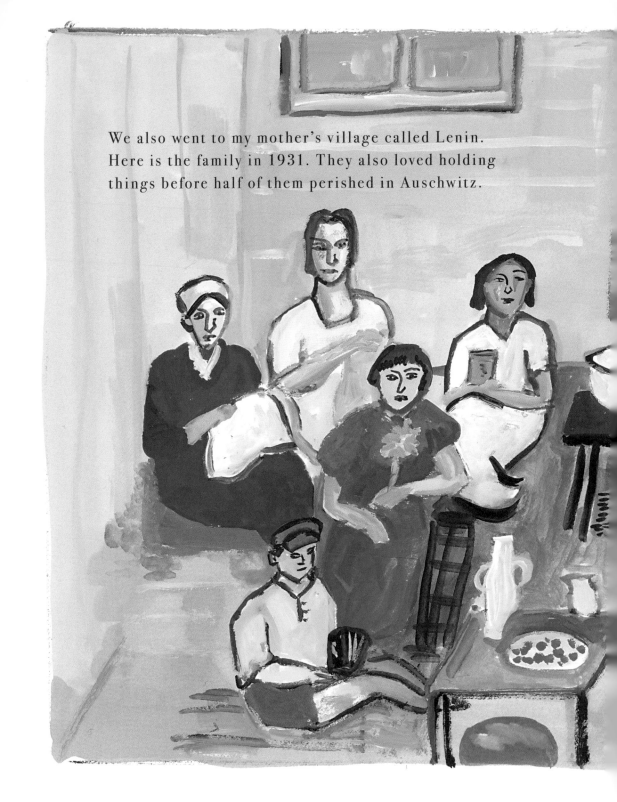

We also went to my mother's village called Lenin.
Here is the family in 1931. They also loved holding
things before half of them perished in Auschwitz.

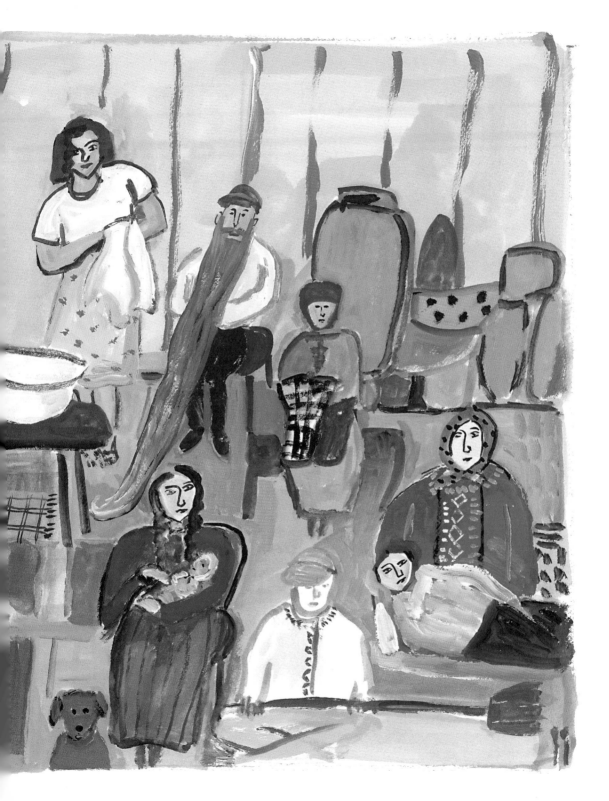

On the trip we stood next to the
river Sluch, where my mother,
who was drowning, was saved by
her grandfather when he threw
his six-foot-long beard into the
river and she grabbed hold.

But you have heard this story
a thousand times before.

If you meet the Holocaust, you can never
escape its grip. You are obliged to feel it
reverberate through all things
for the rest of your life.

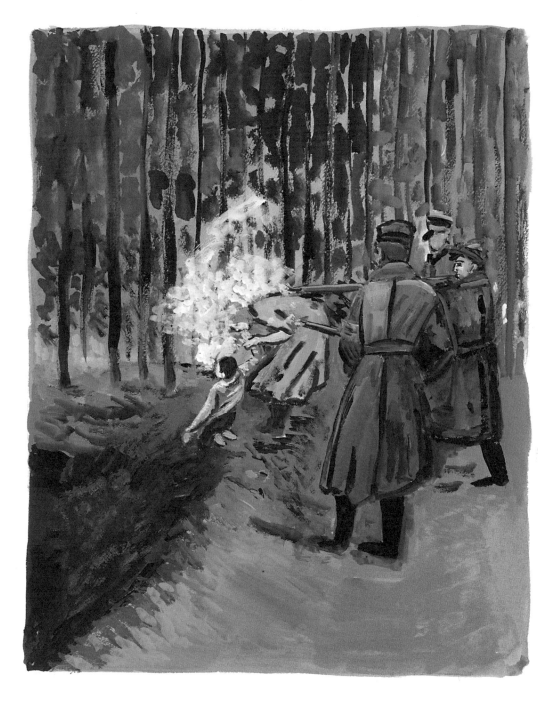

mother holding the hand of her child
as they are being killed by Nazi soldiers

The terrors of the world exist.
And we are wounded.

It would be so nice to never be afraid.
But I am afraid that is just not possible.

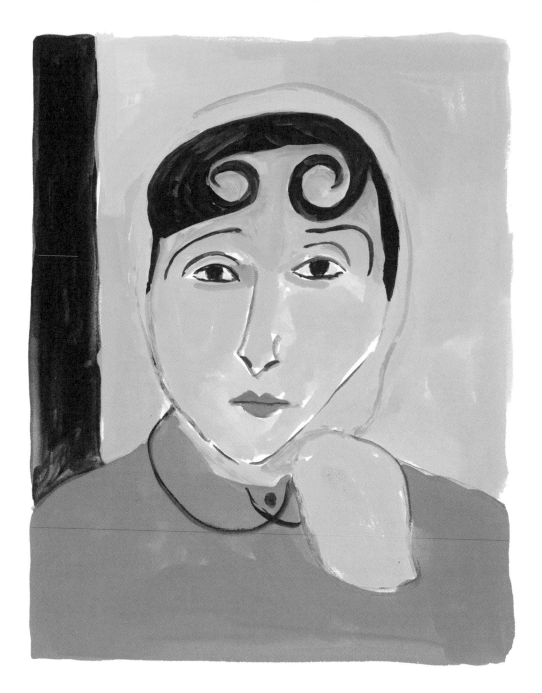

women holding
eyebrows in common

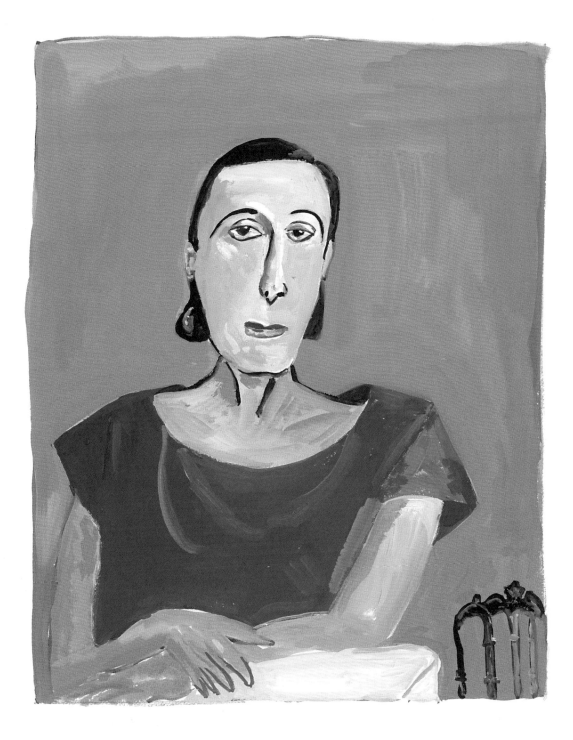

Natalia Ginzburg
holding strong

ill poet Rachel Bluwstein
holding her cane
near the Sea of Galilee

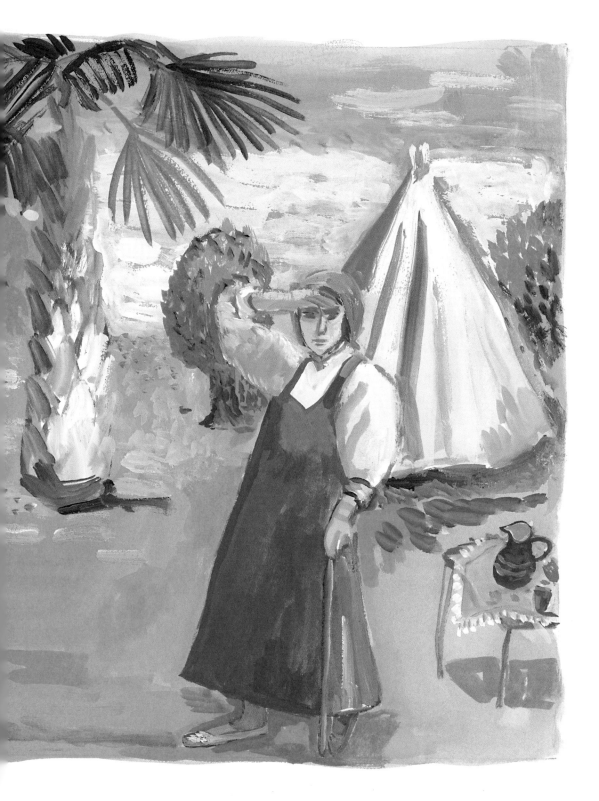

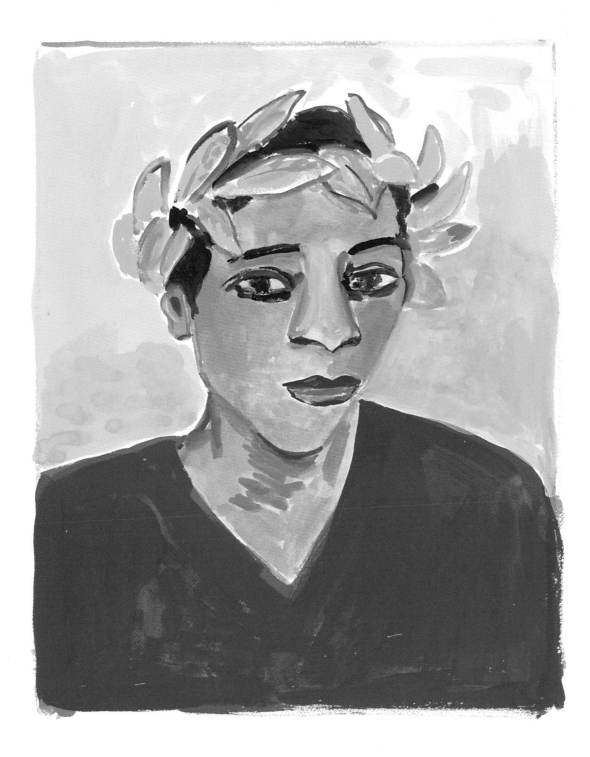

Rose McClendon as Medea
holding laurel wreath

my cousin Iris,
in her dream,
 holding herself up,
swimming in the sky
over the ocean

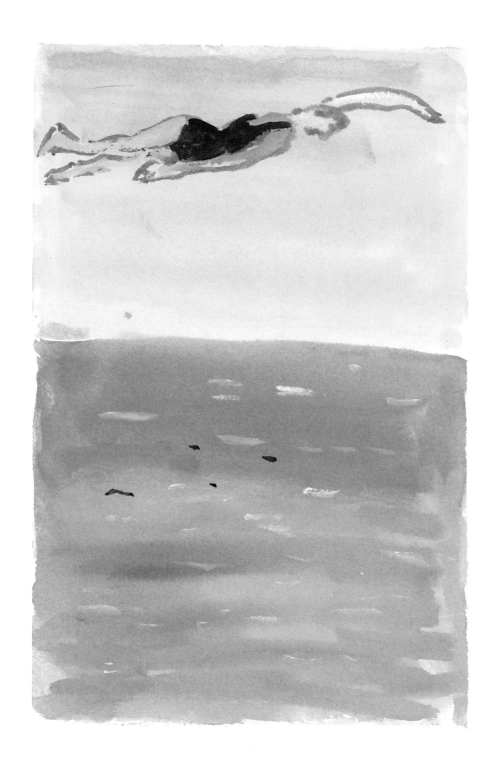

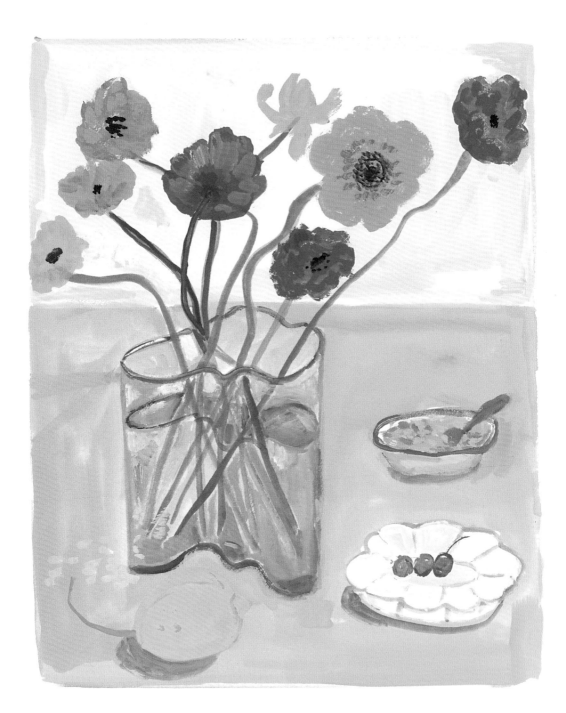

Fruits and Jam

I spend a great deal of time alone.
That is how I work.
Sometimes I dance. Sometimes I sing.
But most of the time I am quiet.

Sometimes, out of nowhere,
I yell something out loud. Full force. Inexplicably.

 For example,

 "Not at eight, darling!"

 "There ARE apples! HA HA!"

 "Well, he really must be killed!"

 "I want to hear it from her lips!"

 "Harangue him! Poor bedraggled soul!"

 "FRUITS AND JAM!"

 And thus the day is passed and noted.

 Quite often when I am with other people
 I run out of things to say.
 And as a companion thought,
 I regret everything I say.

You could say that I hold myself in contempt. But the
feeling passes. And I start talking again. Inexplicably.

In my family, we never had an actual
conversation where ideas were
exchanged and knowledge imparted.

Things were blurted,
 mumbled,
 whispered,
 shouted.

Nothing ever made sense
and nobody understood anybody.
And yet we managed to hurt
each other's feelings all the time.

What did we say to each other?
I just don't know.
How we got through the day is beyond me.

But on some level, this lack of
communicating feels like true
communication. Or that is how
I have come to think of it.

What I can add to that is at the
end of my husband's terribly long
illness, we stopped understanding
each other's sentences.

my daughter Lulu holding a birthday cake
for her daughters Olive and Esme

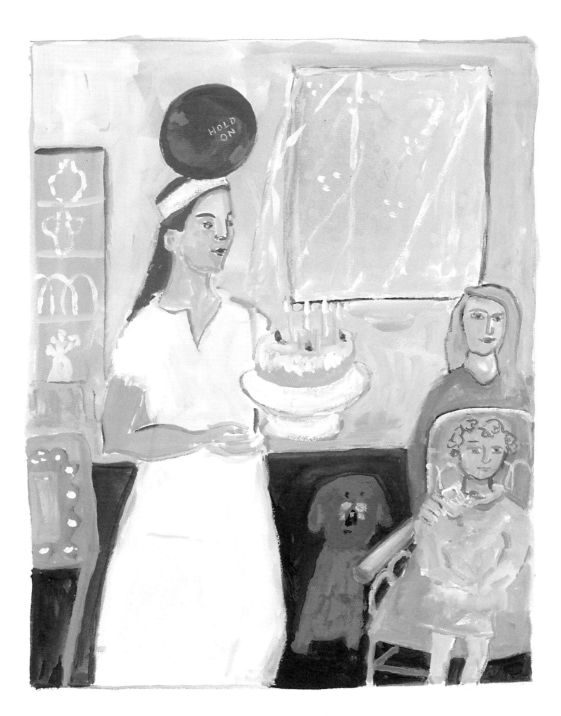

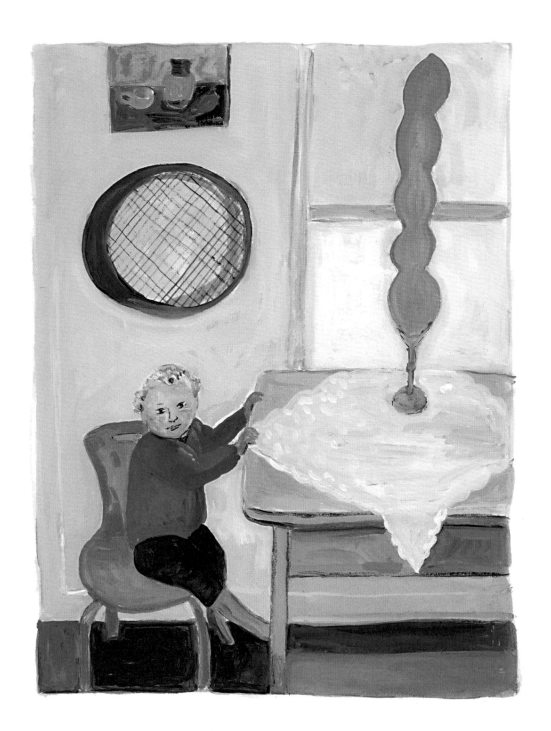

Esme holding table

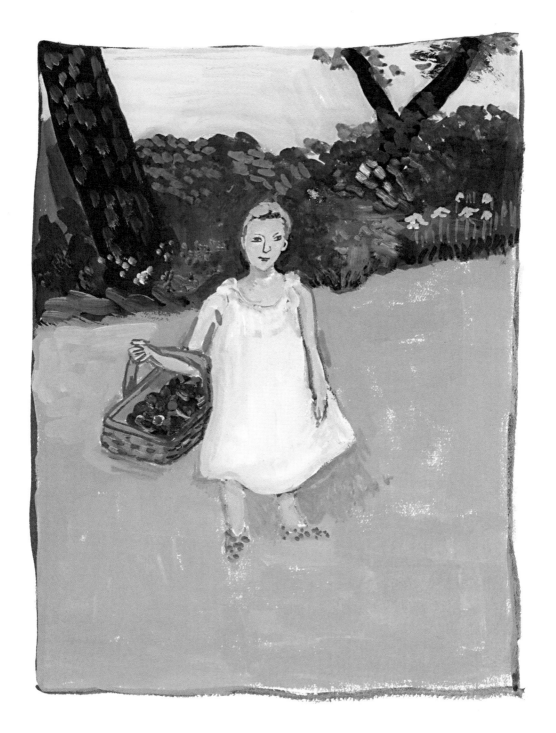

Olive holding basket

my grandmother (in pearls)
holding the weight of the world
on her shoulders
her legs as big as tree trunks

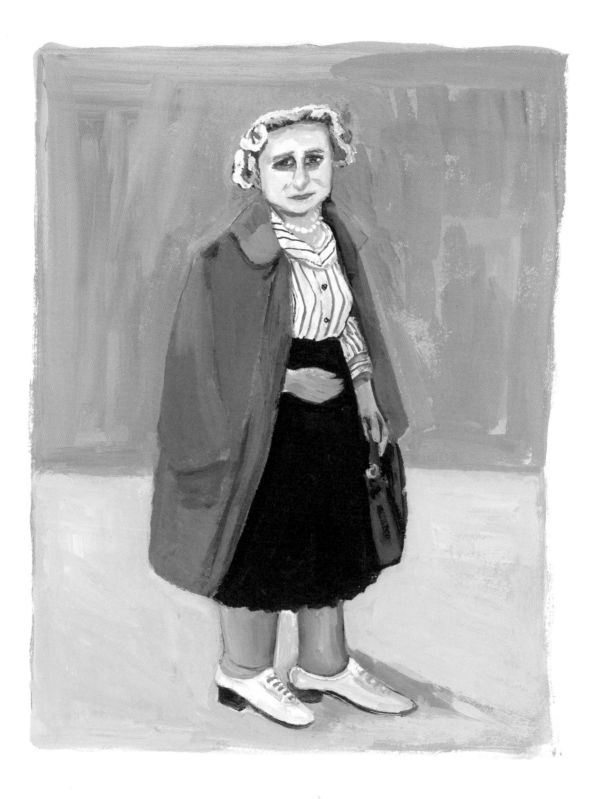

Potatoes

My grandmother was an orphan. When she wanted to marry the man she fell in love with, his parents thought she was not good enough for him and offered her his brother. The brother was the man she married. And he was my grandfather.

My grandfather was not as cunning or successful as his brother. He was a devout man who prayed every day. We loved him. I don't know if he ever spoke to me. I don't remember a single word. But he was a kind presence and looked down at me from a great height. Or I was very small. Which I was.

He only wore white shirts and black pants. Unless he was working. Then he wore white shirts and khaki pants. He ended up working for his brother who may have swindled him out of his rightful earnings. There is some discussion about that in the family.

He loved to eat potatoes that the doctor said he should not. So he snuck them and burnt the pan and my grandmother found out and everyone knew.

My grandmother was always damp from perspiring and terribly beleaguered. Maybe because she did not get to marry the man she loved. She always looked haggard and distraught. But we loved her without question. I look haggard sometimes as well. I am not pleased with that but it is unavoidable.

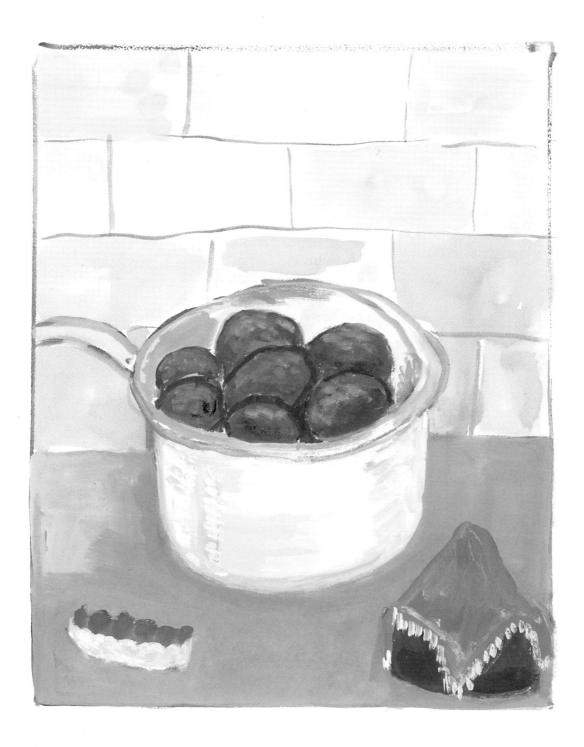

Speaking of men,
they are here.
And that is
not a bad thing.

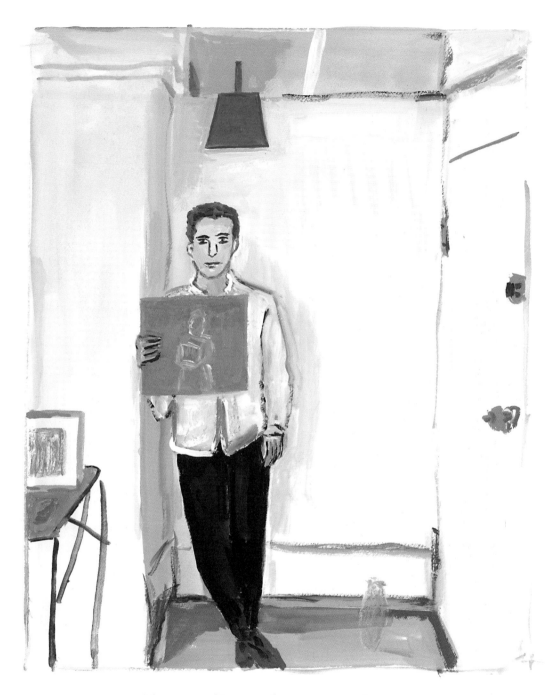

Alex standing under a green dustpan
holding a painting of a woman holding a box

boy standing
in front of a
blackboard
full of numbers
holding his hands
while a man
plays the accordion

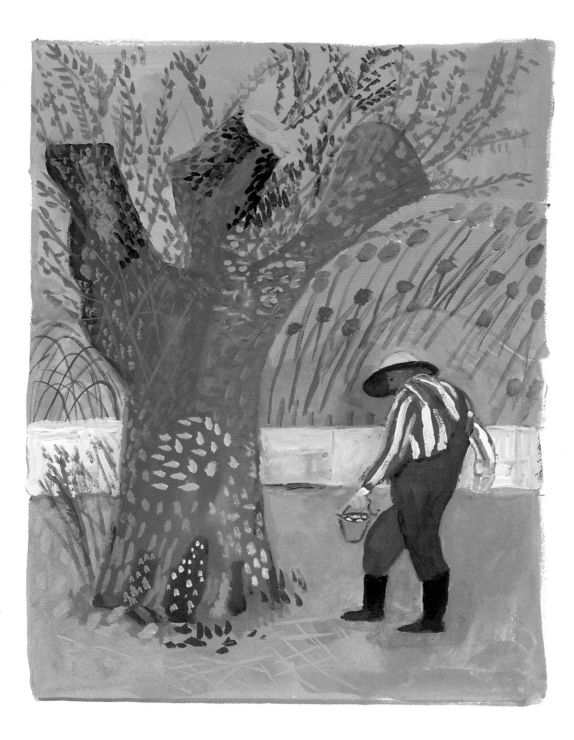

man holding a little bucket carrying
very delicate and fresh eggs
for his dear grandchild
who has not been well

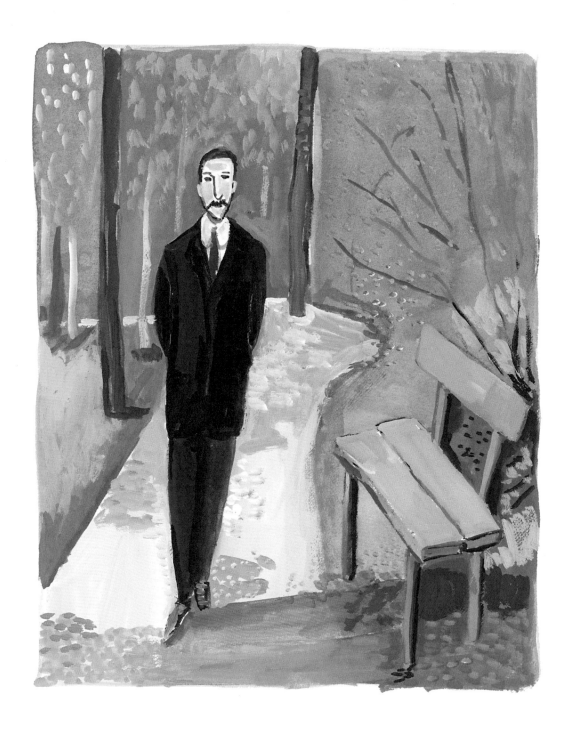

Rilke holding his hands behind his back

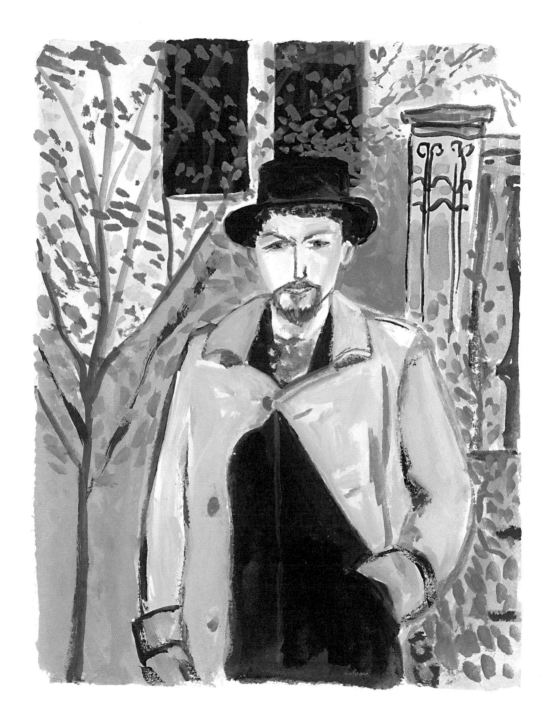

Chekhov holding his hand in his pocket

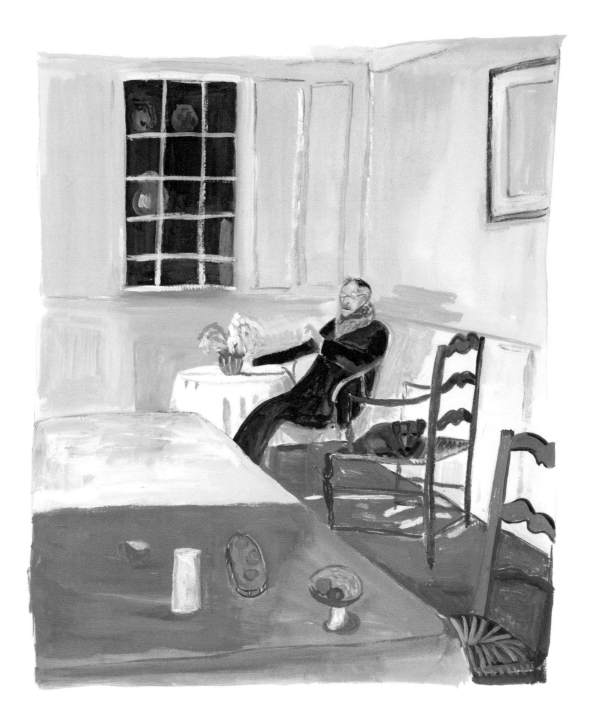

Bonnard holding all the colors on earth

We have talked of women.
And we have talked of men, briefly.

And now a few words on
things holding things.

Everything holds something.

A chair can hold a hat.

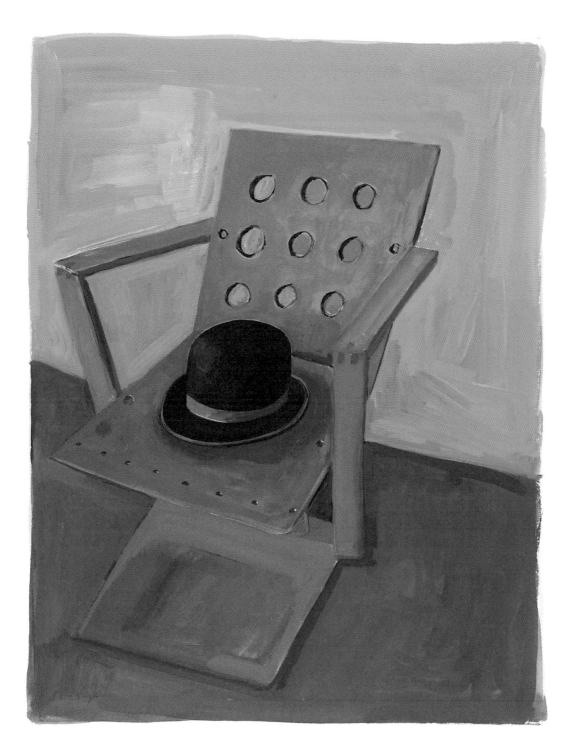

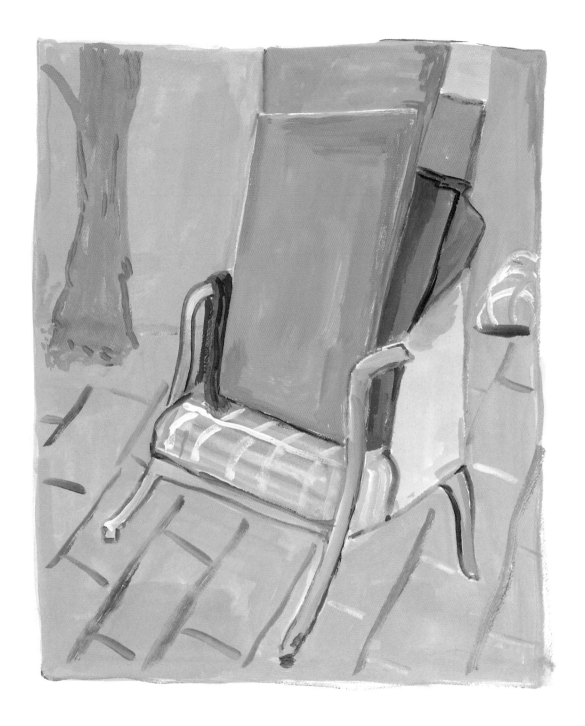

Or a pile of planks destined for the trash

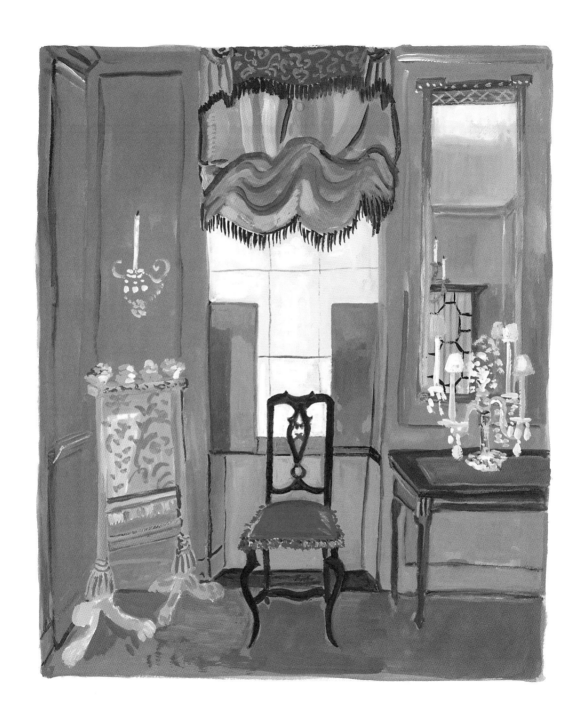

or the plumpest raspberry tassels.

A table can hold a doily.

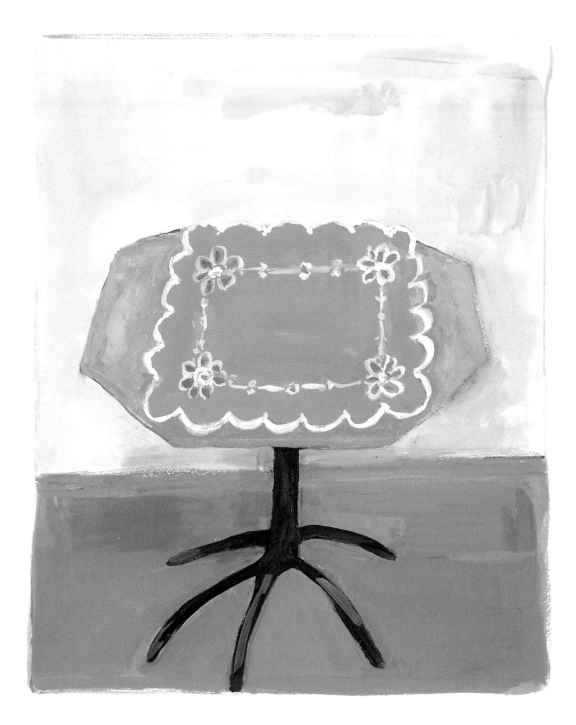

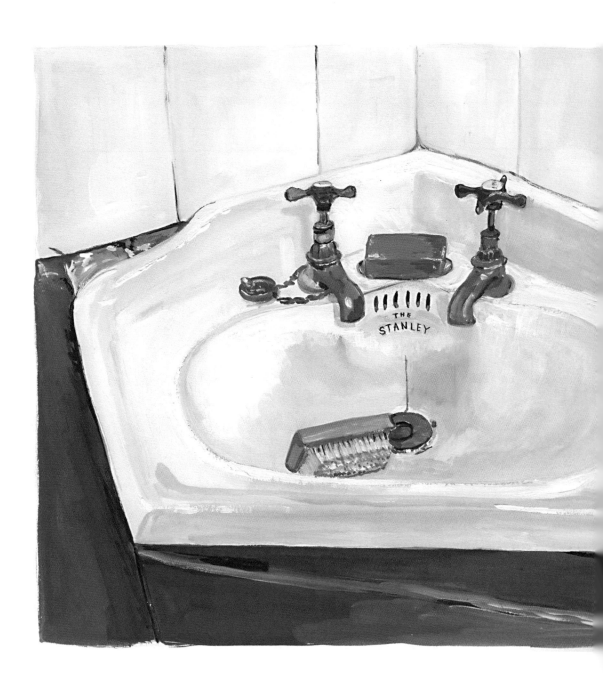

A sink can hold soap.

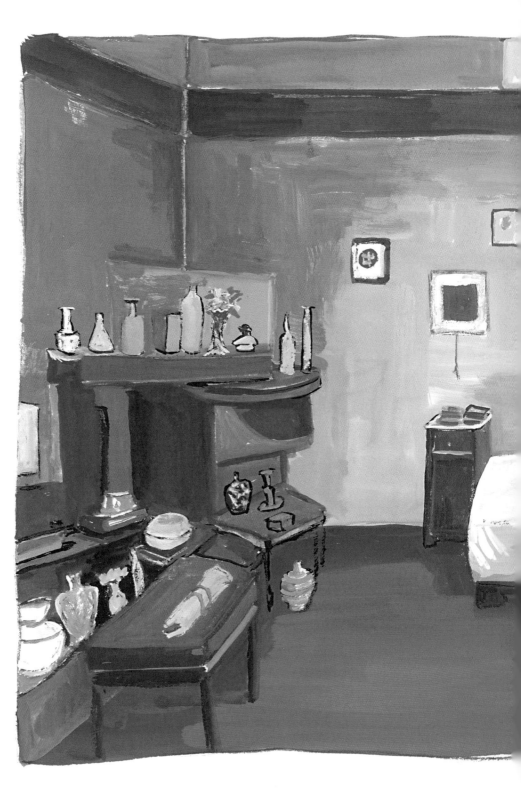

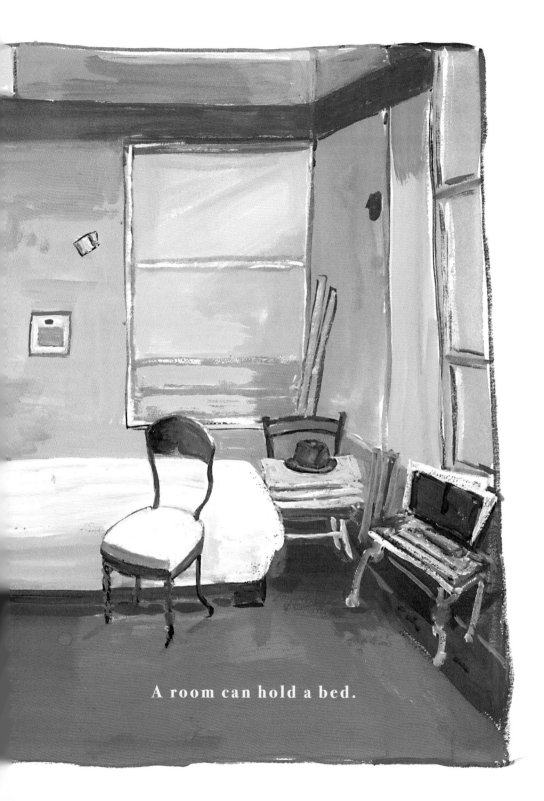

A room can hold a bed.

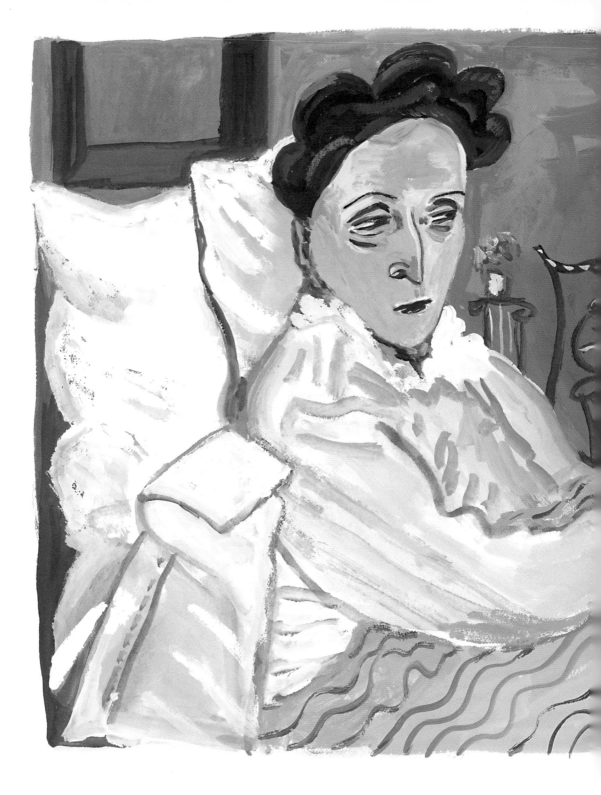

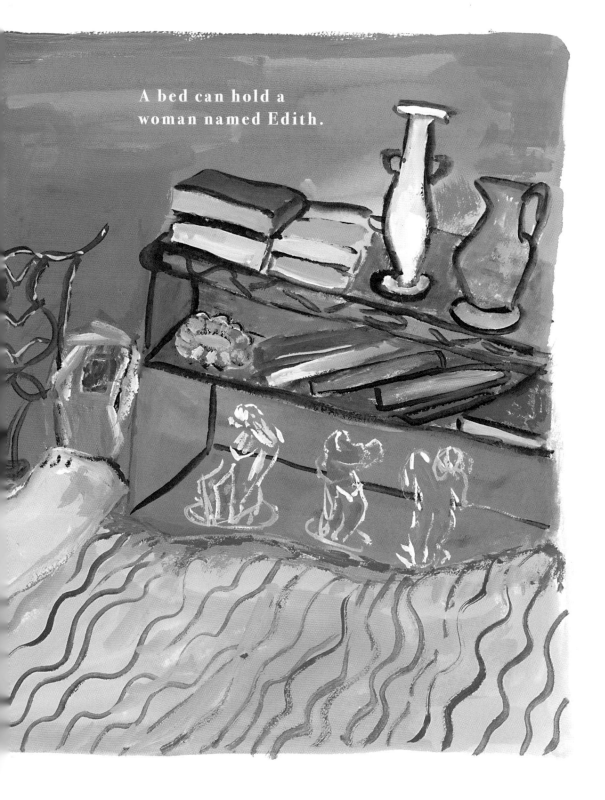

A bed can hold a
woman named Edith.

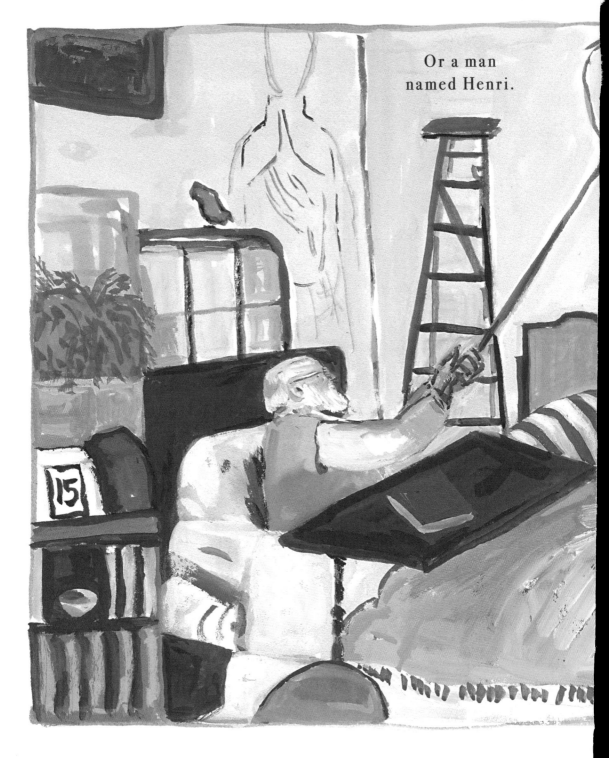

Or a man
named Henri.

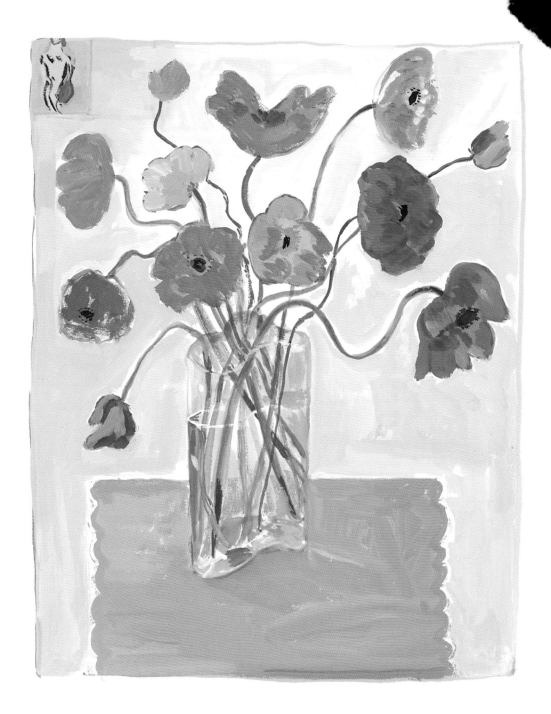

And a vase can hold flowers.

Objects around us hold
our attention and our love.

It is hard work
to hold everything
and it never ends.

You may be exhausted from holding things and be disheartened. And even weep if you are very emotional. Which could be anyone on any day. With good reason.

But then there is the next moment
and the next day and...

hold on

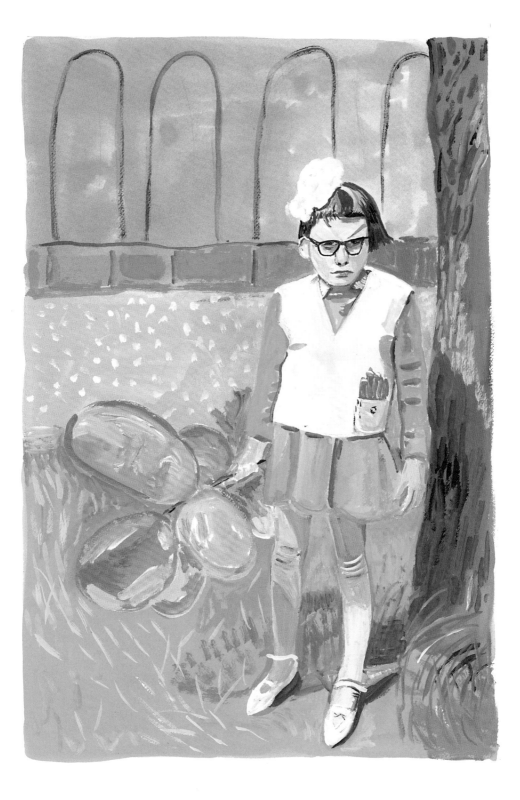

WOMEN HOLDING THINGS

Text and art
© 2022 Maira Kalman

Edit and design
Alex Kalman

HarperCollins books may be purchased for educational, business, or sales
promotional use. For information please email the Special Markets Department
at SPsales@harpercollins.com.

Published in 2022 by
Harper Design
An Imprint of HarperCollinsPublishers
195 Broadway
New York, NY 10007
Tel: (212) 207-7000
Fax: (855) 746-6023
harperdesign@harpercollins.com
www.hc.com

Distributed throughout the world by
HarperCollins Publishers
195 Broadway
New York, NY 10007

ISBN 978-0-06-284667-9
Library of Congress Control Number: 2022934017
Printed in Bosnia and Herzegovina
First Printing, 2022

24 GPS 6

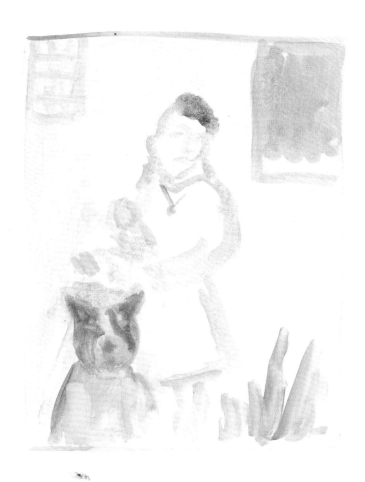

for lulu and alex
who hold everything